South Dakota
Wildlife
impressions

FARCOUNTRY
PRESS

photography and text by
Dick Kettlewell

ISBN 10: 1-56037-386-5
ISBN 13: 978-1-56037-386-5
Photographs © 2006 Dick Kettlewell
© 2006 Farcountry Press
Text by Dick Kettlewell

For more information about our books write Farcountry Press,
P.O. Box 5630, Helena, MT 59604; call (800) 821-3874; or visit
www.farcountrypress.com.

Created, produced, and designed in the United States.
Printed in China.

10 09 08 07 06 1 2 3 4 5

FRONT COVER: Bison cow and calf nuzzle in the summer sun.

BACK COVER: Pronghorn doe and fawn rest on the grassy prairie.

TITLE PAGE: A stately elk bull feeds in a river canyon in the southwestern part of the state.

RIGHT: Bison cows and calves make their way through the grasslands of Custer State Park en route to a popular watering hole.

BELOW: A large bison bull spends an autumn afternoon at rest in the grasslands of Wind Cave National Park in the southern Black Hills.

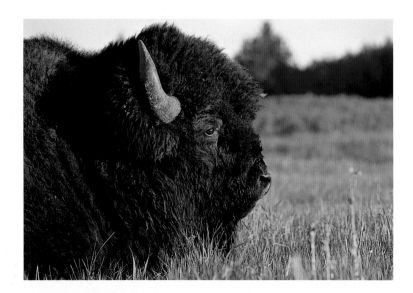

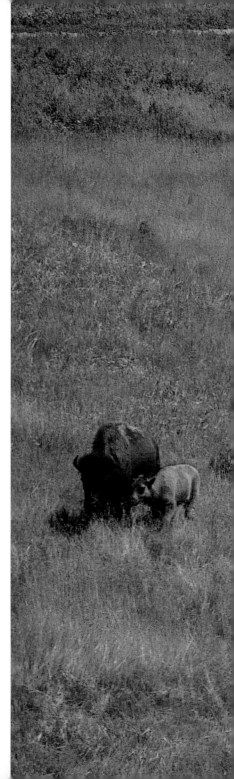

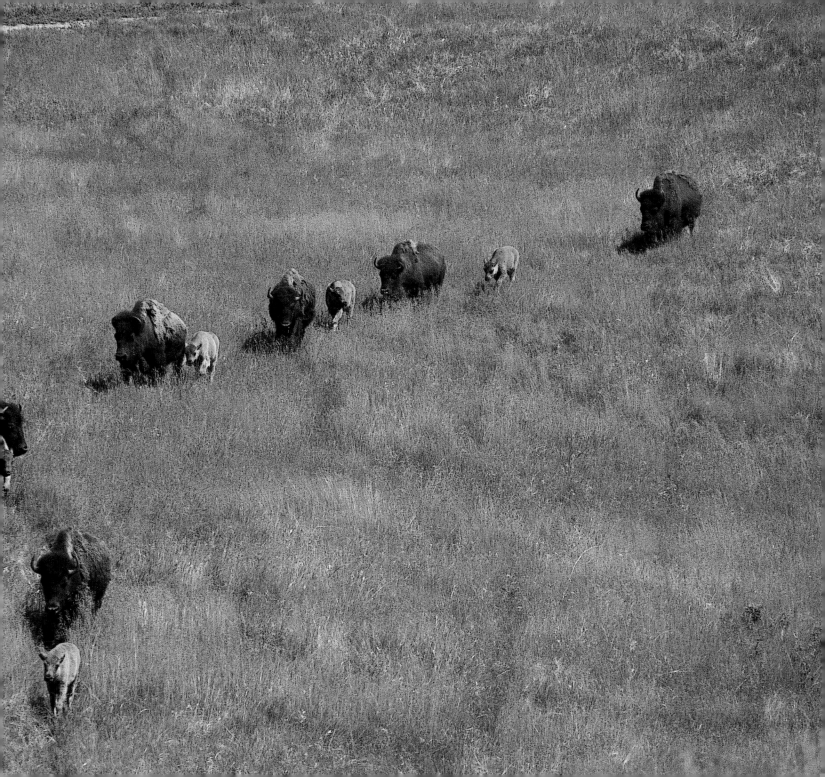

Introduction

by Dick Kettlewell

A pronghorn buck suddenly lifts his head above the tall grass. He scans the prairie ravine and listens hard, his ears twitching and turning. The buck senses something is afoot.

Soft sunlight, filtered by a thin layer of clouds on the eastern horizon, spills across the sprawling grasslands, signaling the start of another day on the South Dakota prairie. A pronghorn doe and her two fawns continue their morning feed, unaware of the nervous buck nearby.

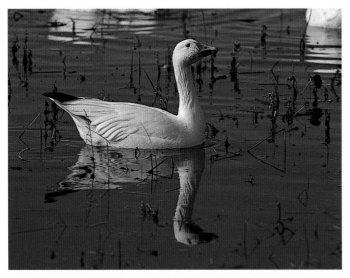

A snow goose swims in the waters of the Sand Lake National Wildlife Refuge. As many as 300,000 snow geese pass through the area during spring migration.

With the sparkle of dawn light in his eyes and on his tall antlers, the buck climbs to the top of the hill bordering the ravine and gazes eastward with a fixed stare. After a quick glance back to the west and then north, the animal relaxes once again and slowly lowers his head and resumes the business at hand: eating.

Rays of sun spread from a large break in the silky clouds, washing the grasslands in amber light.

Movement—in the grass about twenty yards away. The pronghorn buck stands erect, eyes fixed on the grass. He takes a couple of steps toward it, nose in the air.

The head of a large coyote pokes out from the tall grass, and then the predator bursts forward. The buck flinches and turns, letting out a birdlike sound as he bolts—an alarm signal among these creatures of the prairie. The pronghorn doe stands up straight and takes off, giving the same alarm to her fawns. Now about three months old, the two youngsters understand what to do. Pronghorn fawns are on their feet less than 30 minutes after birth and are able to keep up with the adults after six weeks. Together, they dash across the prairie ahead of their mother, their young legs a blur.

The coyote comes to within a few feet of the buck, but the chase is over quickly. The coyote stops and pants as the pronghorns disappear over a ridge, their legs propelling them forward at speeds of up to 65 mph.

It's just another morning on the South Dakota grasslands.

The coyote and the pronghorn (sometimes called antelope, although technically it is not one) are two of many remarkable and varied creatures that thrive in the ecosystems of South Dakota—the prairies, wetlands and rivers, and the Black Hills.

The state is located within the immense central North American prairie that extends about 2,000 miles from Texas to Canada. Like this vast expanse, South Dakota is blessed with broad skies, spacious landscapes, and spectacular wildlife.

Many species native to this region were pushed to near extinction by early European and American settlers. By the early twentieth century, many animals such as bison, pronghorns, bald eagles, and trumpeter swans were reduced to only a few hundred each.

Today, through the efforts of numerous individuals and private and public agencies, many threatened animal populations have

made remarkable recoveries. South Dakota has reaped the rewards. From semi-arid prairies to river and lake wetlands to the alpine country of the Black Hills, the state teems with wildlife in numbers reminiscent of times past.

The American bison, the august creature known by many as "the monarch of the plains," has bounced back after nearly disappearing from the landscape.

The pronghorn, an animal so unique that it is the only member of its genus *Antilocapra americana,* now numbers more than 50,000 across the state.

Other smaller plains creatures include black-tailed prairie dogs, jackrabbits, tree and ground squirrels, foxes, badgers, marmots, raccoons, and, of course, coyotes.

South Dakota skies, grasslands, lakes, and rivers abound with a variety of birds native to the region, in addition to many others that pass through on migratory routes during spring and autumn.

Large and beautiful birds of the prairie, such as the sage grouse and prairie chicken, put on magnificent courtship displays each spring. The ring-necked pheasant, which inhabits nearly every part of the state, remains one of the most successful transplants of a wildlife species ever.

Nesting pairs of trumpeter swans are found in many of the state's marshlands, as well as in the Lacreek National Wildlife Refuge, which is a major wintering ground for these fabled creatures.

Each spring the skies are filled with thousands of snow geese and sandhill cranes heading to ancient nesting grounds in the Canadian territories—and as far north as the Arctic Circle.

One of the treasures of South Dakota is the Black Hills, an area about 120 miles by 60 miles in the state's southwestern corner that juts up from the prairie to heights of more than 7,000 feet. Great numbers of elk, deer, and bighorn sheep roam its alpine forests and meadows, and mountain goats climb the rugged peaks and crests of its central granite country.

An unforgettable portrait of the wild world awaits all who roam the remarkable landscape of South Dakota.

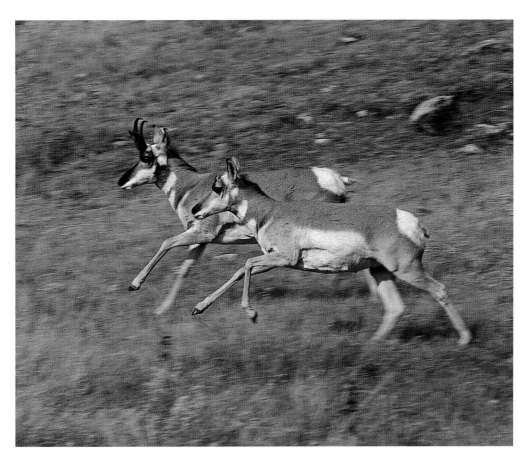

Two pronghorns race up a ridge.

A flock of sandhill cranes heads
north to nesting grounds.

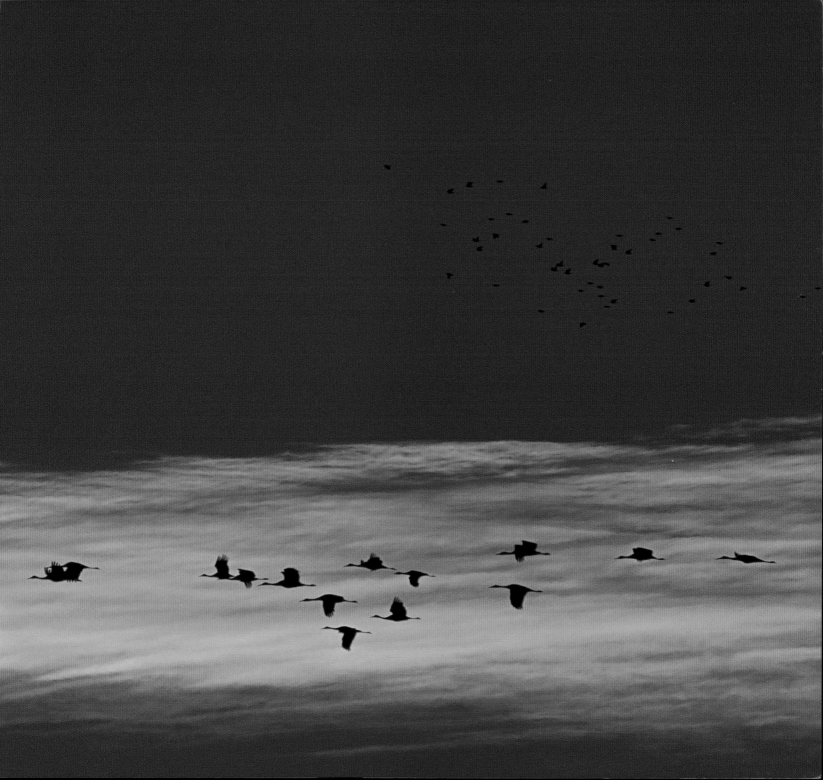

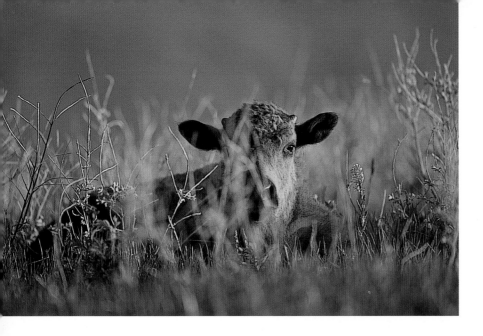

LEFT: Sunrise illuminates a bison calf peering through the prairie grass.

BELOW: Black-tailed prairie dogs live in social groups called "towns." These pups are in Badlands National Park.

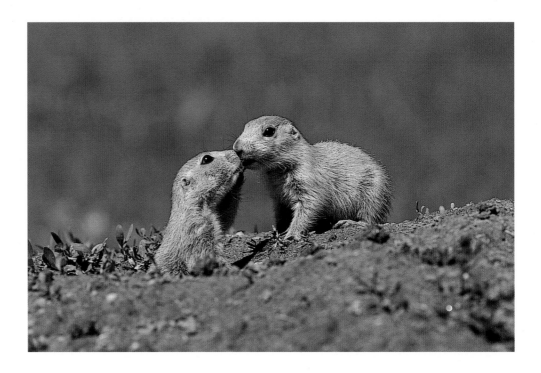

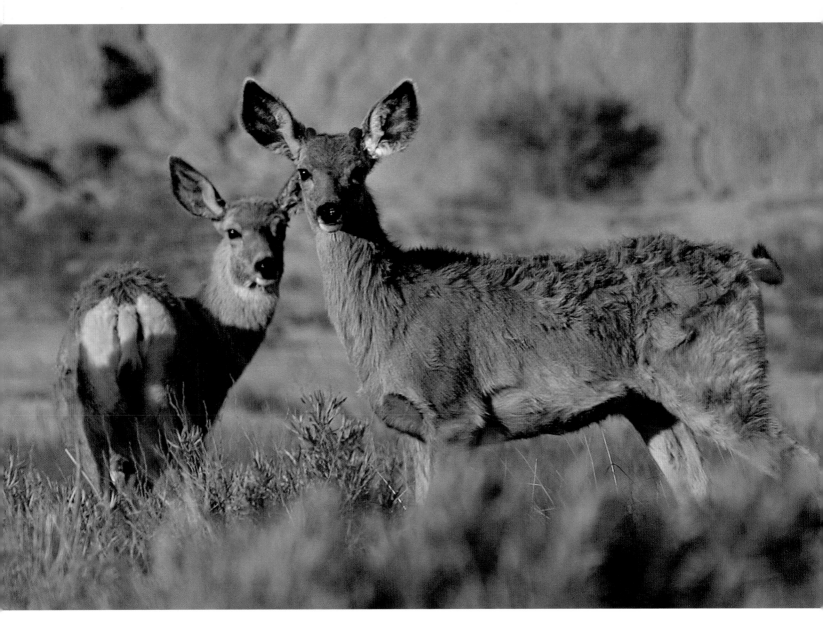

Mule deer are a common sight throughout the year on most of South Dakota's public and private grasslands.

RIGHT: The cottontail rabbit is preyed upon by nearly every predator on the prairie. It constantly scans the environment for danger, even while eating.

FAR RIGHT: This pronghorn fawn, about two days old, will spend most of its first six weeks curled up and lying still in the grass to escape detection from predators such as golden eagles, bobcats, and especially coyotes. Its mother will return several times a day to care for and feed the fawn.

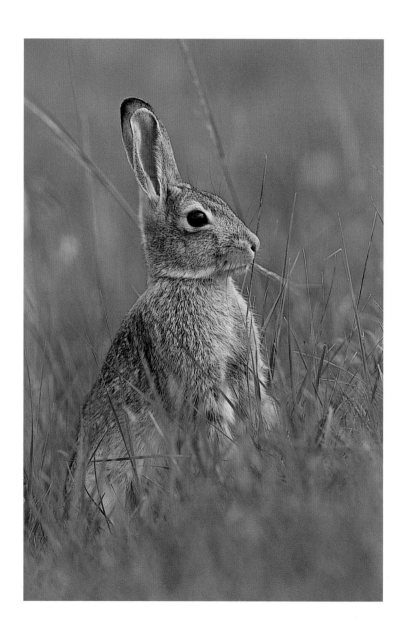

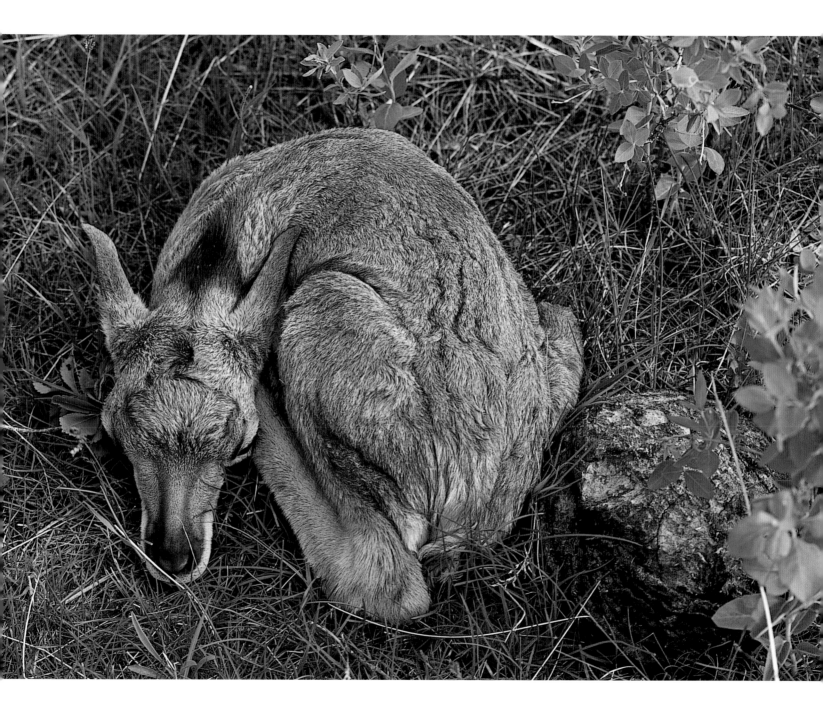

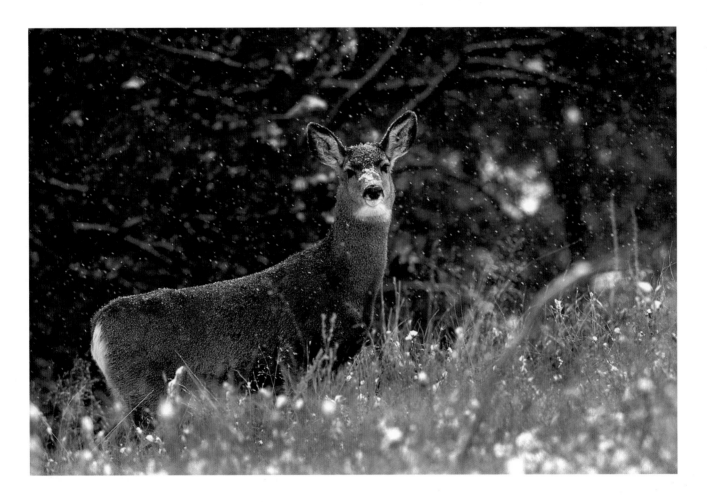

ABOVE: A mule deer feeds at the forest's edge during a morning snowfall.

FACING PAGE: A coyote pauses and redirects its search for rodents in the snow. This fabled creature is featured in countless legends from many different Native American tribes. The coyote is the state animal of South Dakota.

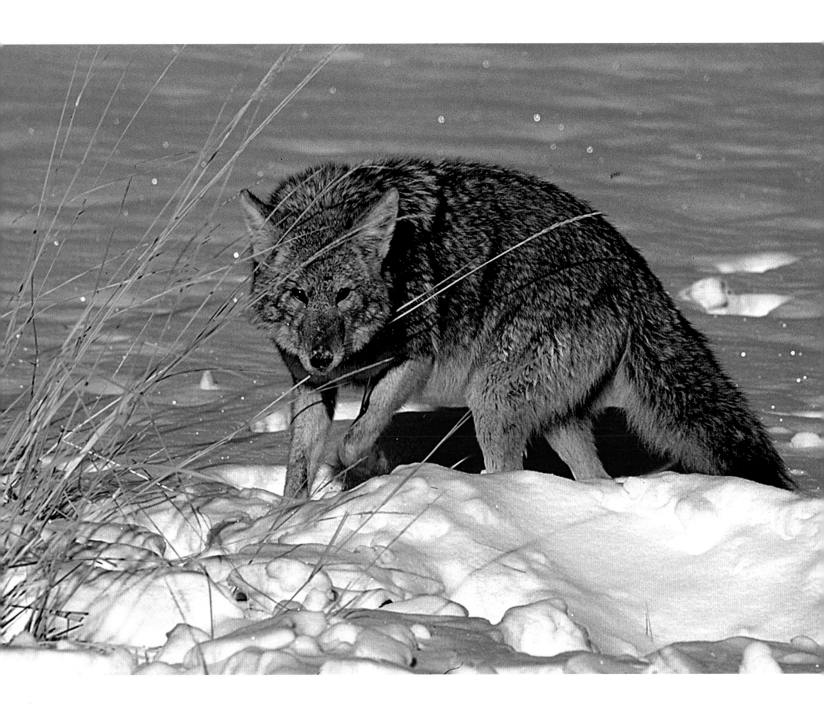

FACING PAGE: The reflection of a double-crested cormorant drying its wings is cast across the still waters of a prairie pond.

BELOW: White pelicans, from a colony numbering about a hundred, socialize and preen on a midsummer's day at Bear Butte Lake in western South Dakota.

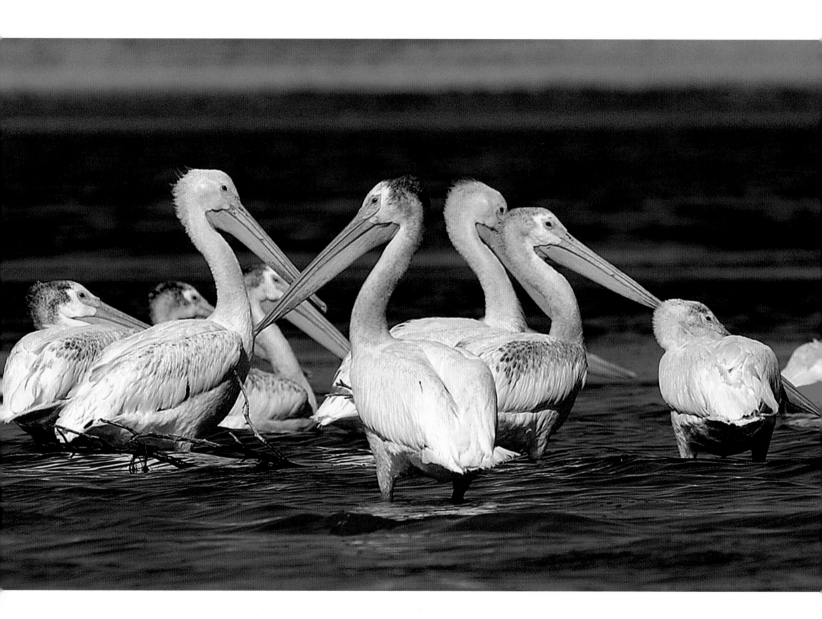

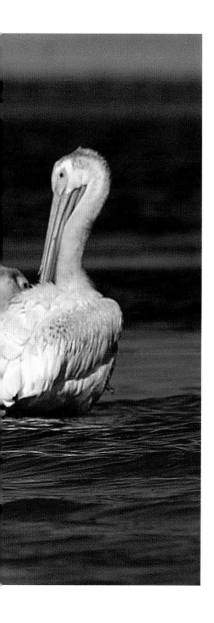
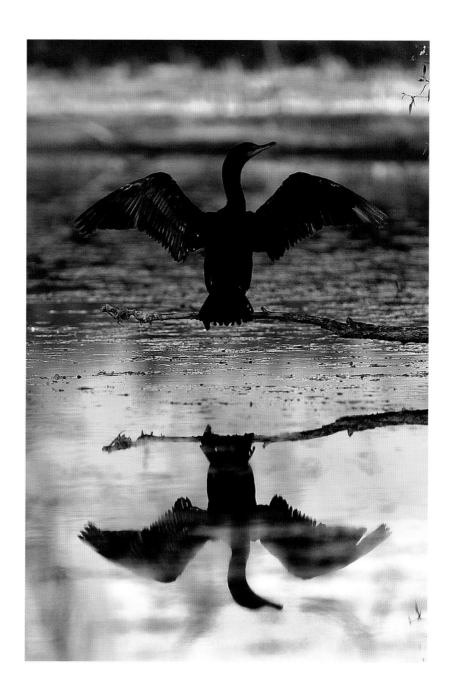

FACING PAGE: A young white-tailed deer buck surveys its surroundings in the high country of the Black Hills.

BELOW: The courtship display of the male sage grouse is one of the most spectacular of all prairie birds. The males make a bubbling sound similar to that of a percolating coffee pot.

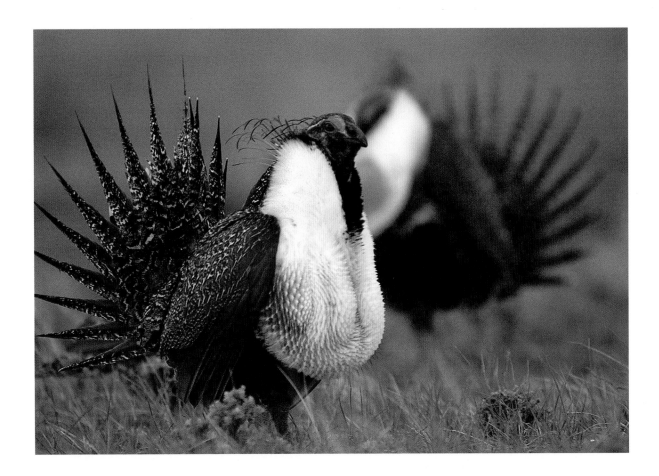

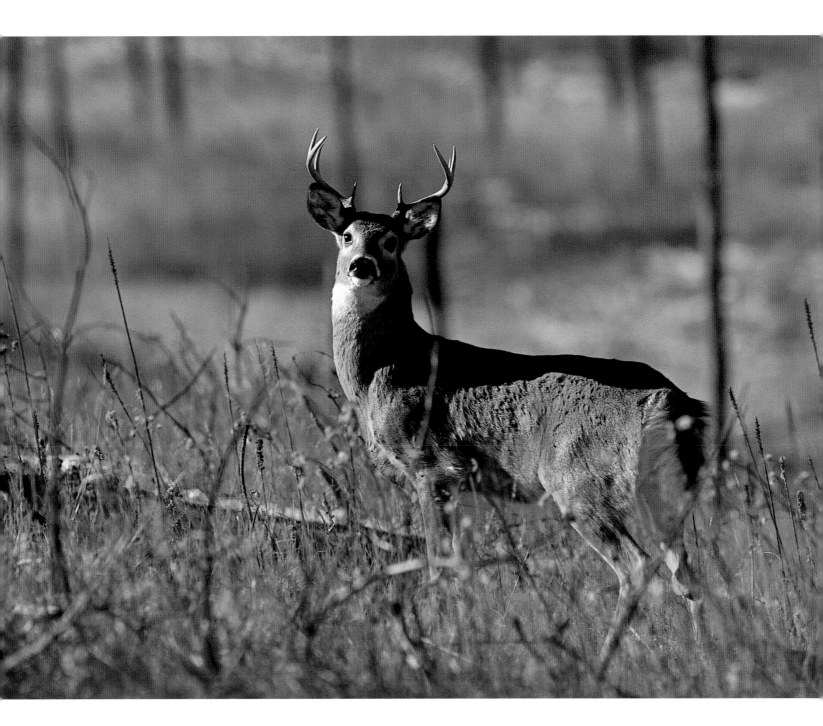

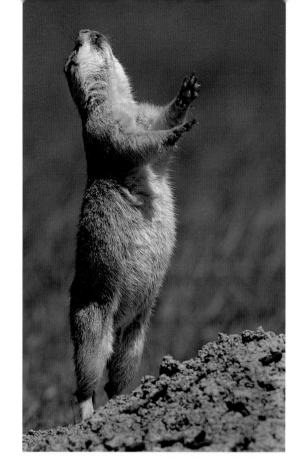

RIGHT: It's late May, and two bison bulls engage in play on the prairie. When the rut begins in mid-July, the interactions between these mammoth creatures become more aggressive.

LEFT: Sounding the alarm, a black-tailed prairie dog—which is actually a ground squirrel—tips off the town to the approach of a predator.

BELOW: The warning is heeded by this female, who gathers her young at the entrance of the burrow. These small creatures are on 24-hour predator alert.

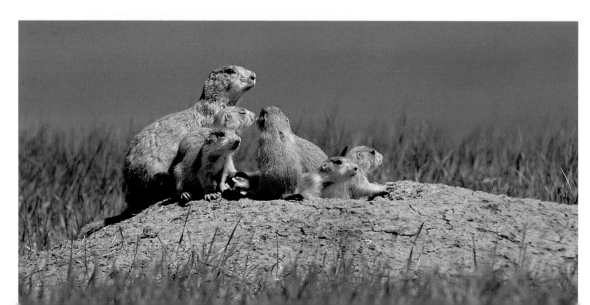

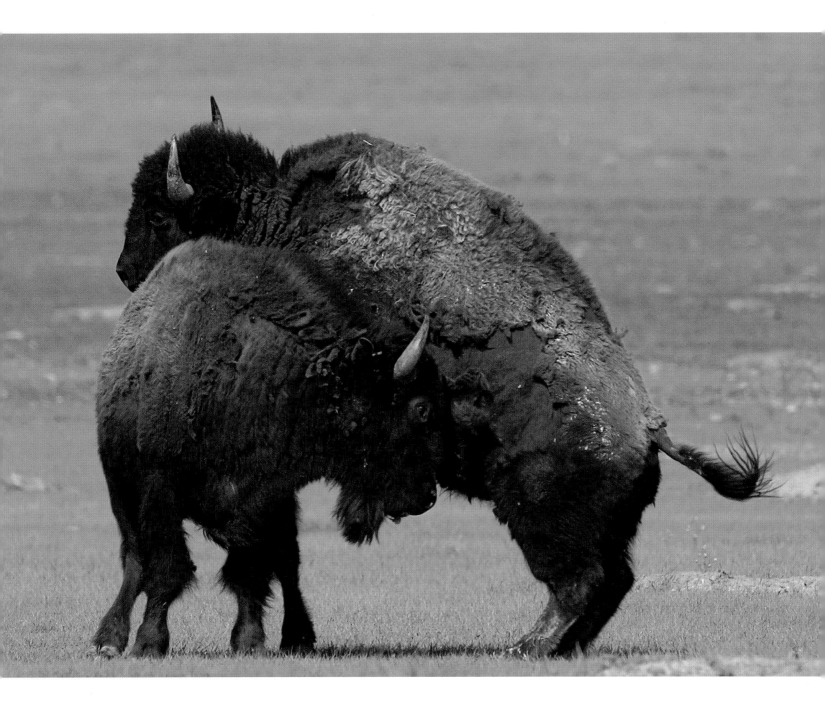

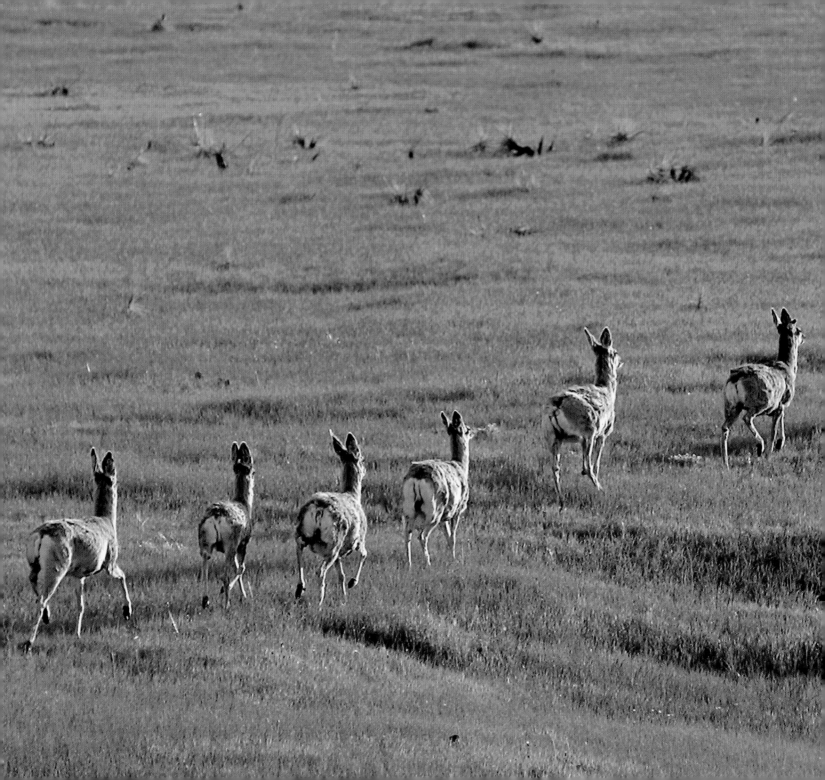

LEFT: A herd of mule deer moves across a lush, green prairie in Badlands National Park.

BELOW: This pronghorn doe nurses twin fawns, which are about a week old. Her rich milk nourishes and fuels their growth so they can run with the adults by the age of six weeks.

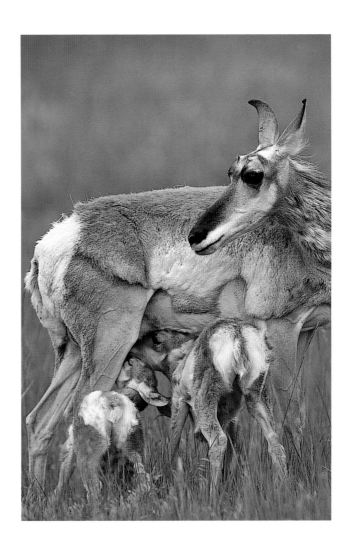

RIGHT: A month-old bison calf splashes and plays in a drinking hole. All bison calves are born a golden-brown color but change to chocolate brown by the time they are three to four months old.

BELOW: A paddle-shaped tail and webbed hind feet allow the beaver to ply the waters in which it resides.
PHOTO BY SOUTH DAKOTA OFFICE OF TOURISM/CHAD COPPESS

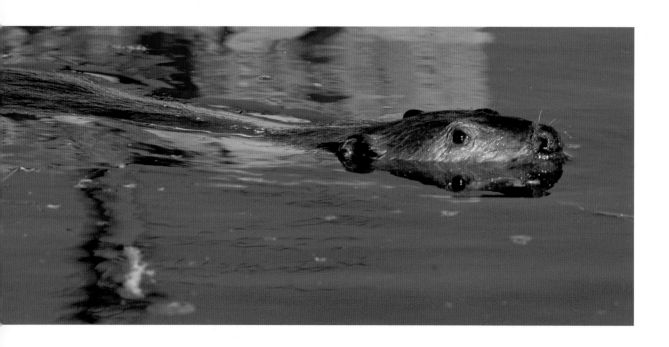

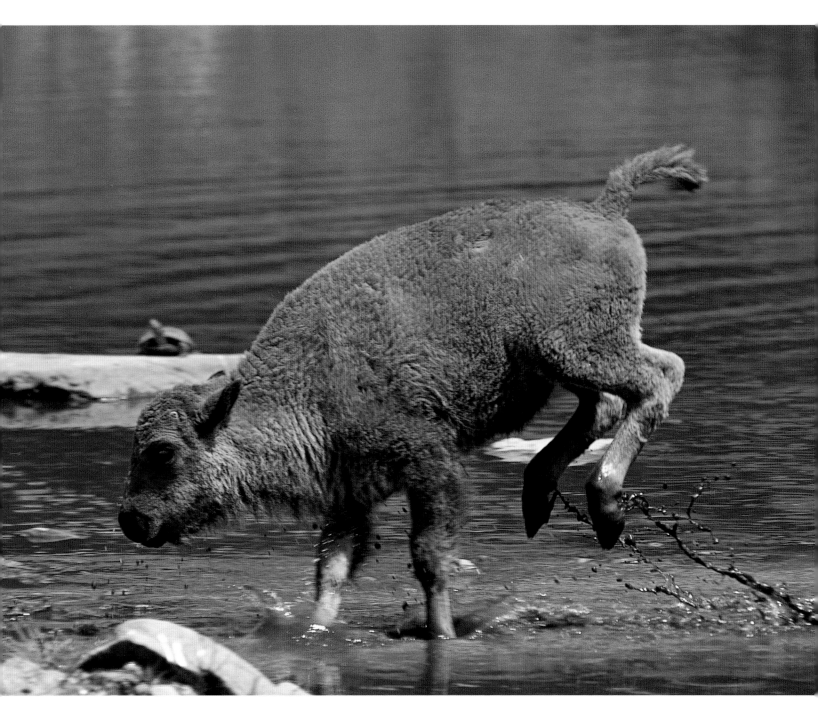

FACING PAGE: At sunset, trumpeter swans walk on a frozen marsh pond at the Lacreek National Wildlife Refuge.

BELOW: The male sage grouse is well camouflaged on the prairie—which is essential for evading such predators as coyotes, bobcats, and golden eagles.

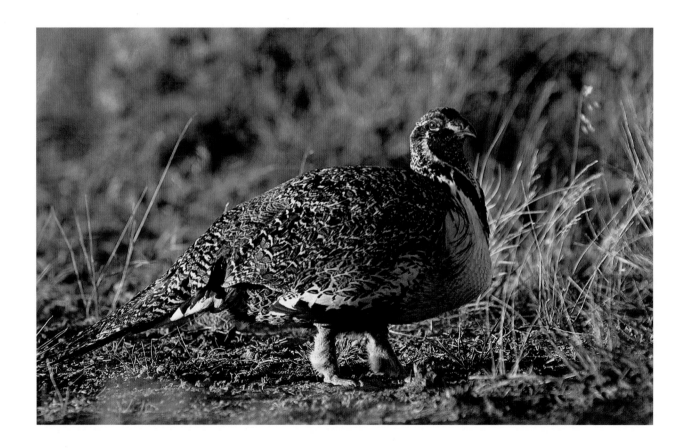

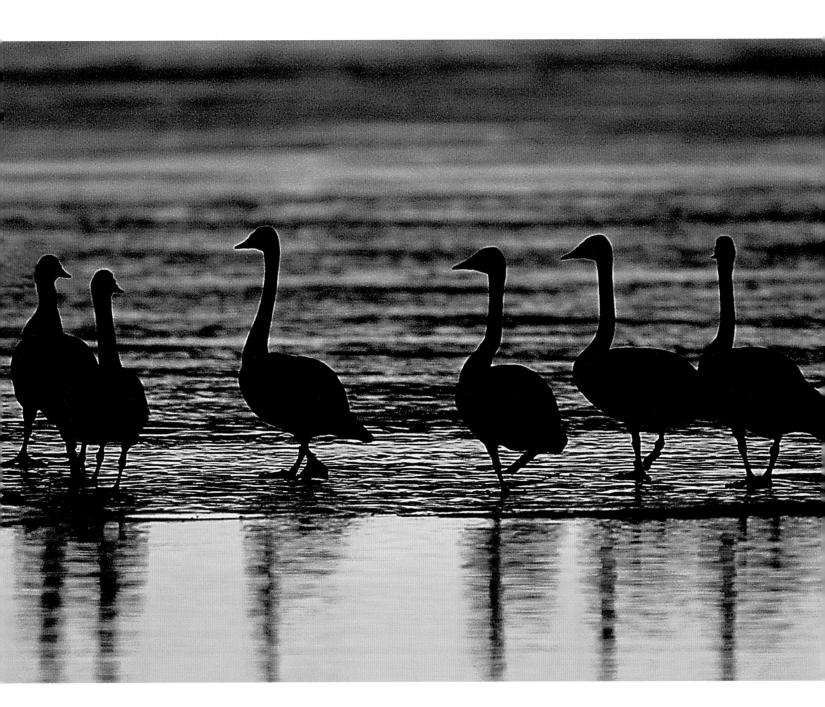

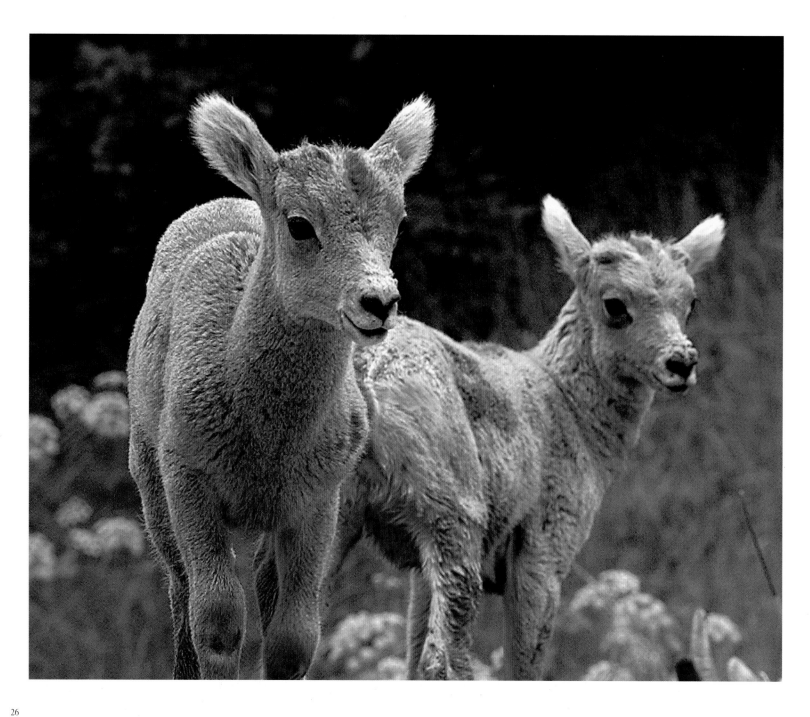

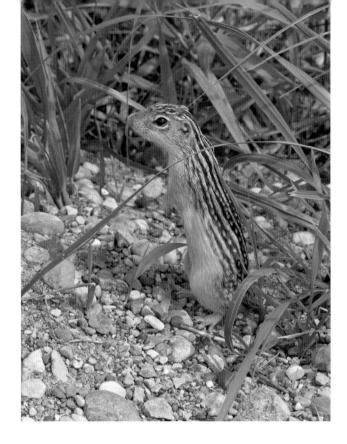

LEFT: The thirteen-lined ground squirrel is the most common ground squirrel in the state. It is easily identified by the broken stripes on its sides and back.
PHOTO BY SOUTH DAKOTA OFFICE OF TOURISM/CHAD COPPESS

FACING PAGE: It's hard to believe that these six-week-old bighorn sheep lambs will one day become the mighty horned centurions that clash in the high-country canyons of the central Black Hills.

BELOW: The swift black-tailed jackrabbit cannot rely entirely on speed to avoid predators; it must lie low in cracks and crevices to avoid detection.

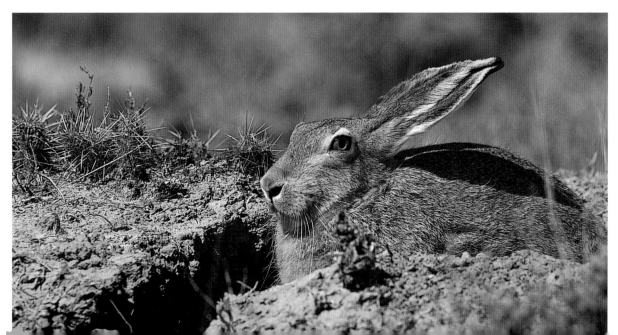

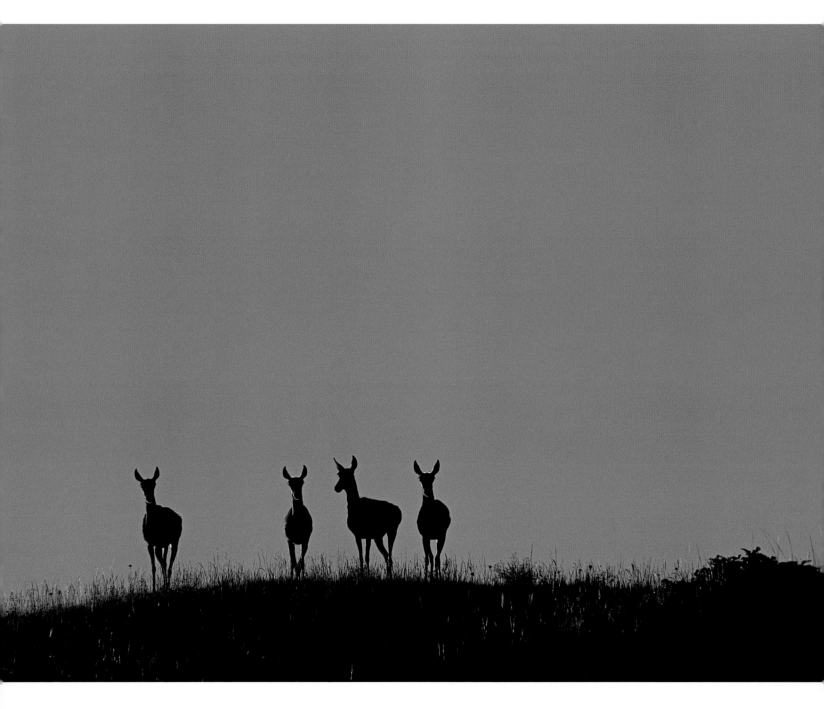

LEFT: Four pronghorn does are silhouetted along a prairie ridge.

BELOW: In midsummer velvet, a trio of mule deer bucks enjoys a morning feeding.

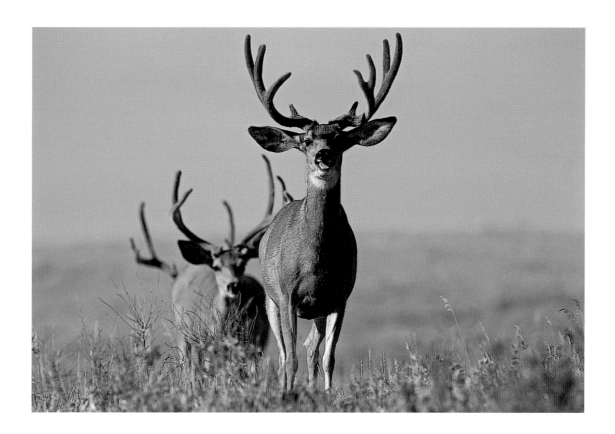

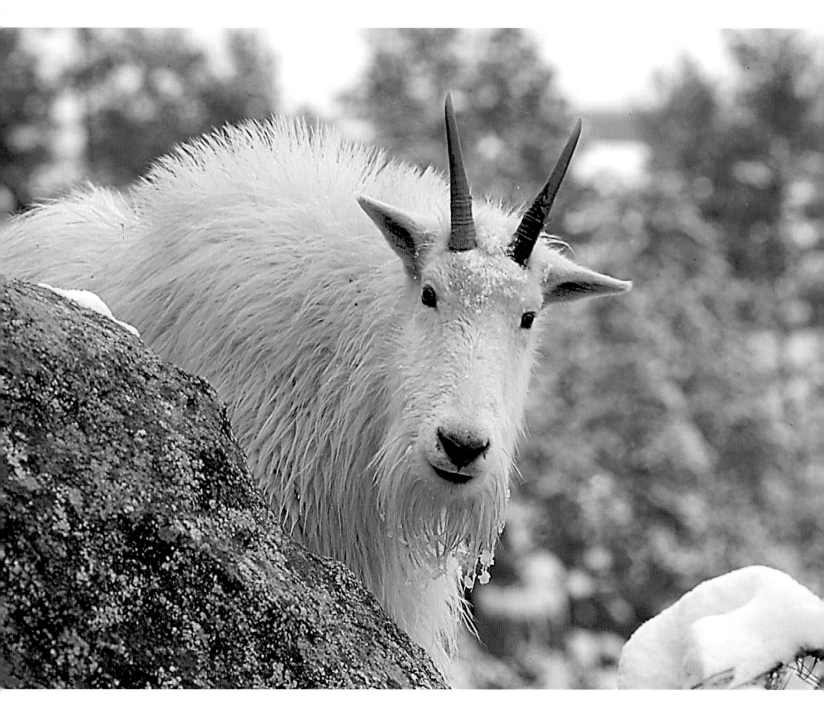

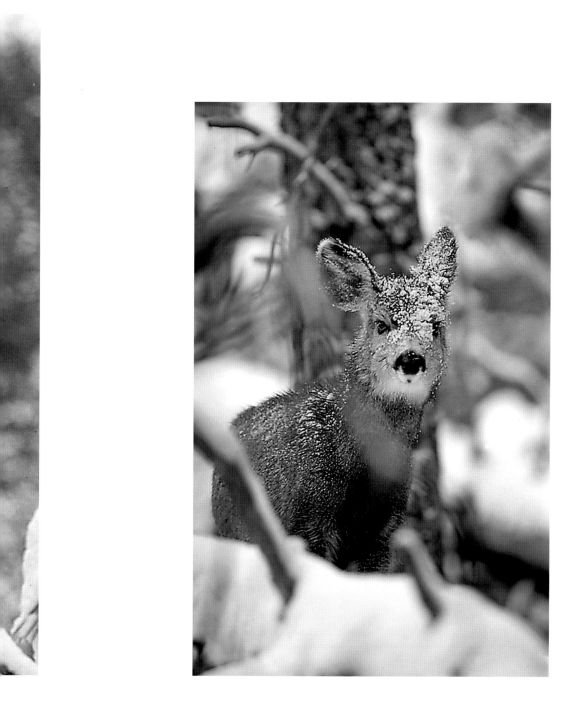

LEFT: A snow-covered white-tailed deer feeds along the shore of Deerfield Lake.

FAR LEFT: Ice and snow hang from the coat of this mountain goat nanny. She is searching the boulders of the central Black Hills' granite country for lichen, a food that will help sustain her throughout the long high-country winter.

Members of the weasel family, badgers spend most of their time digging for rodents and are most active at night. PHOTO BY SOUTH DAKOTA OFFICE OF TOURISM/CHAD COPPESS

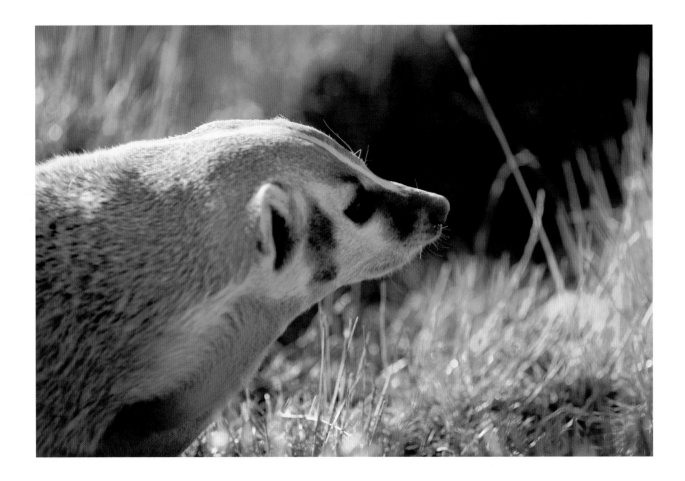

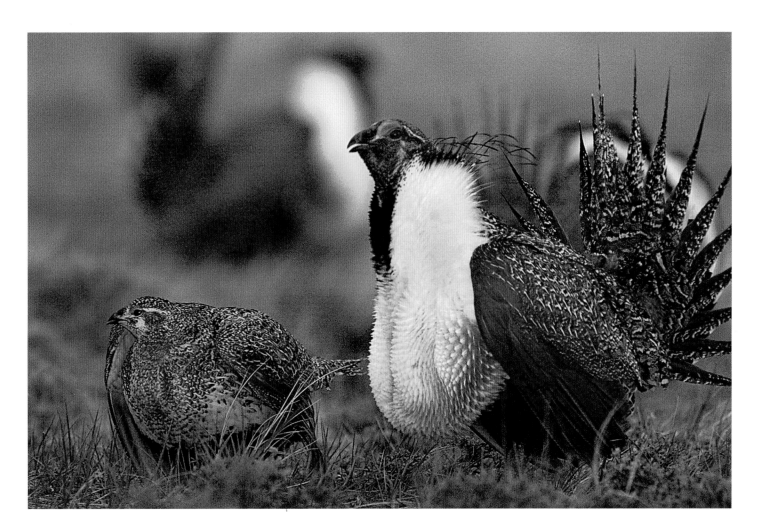

A sage grouse hen, at left, submits to the advances of a rooster in full courtship display at the mating ground known as a lek. During this display, the male shows off its ornate plumage, which includes head plumes, eyebrow patches, and a collar of bright, white feathers. The birds will return to the same ground each year if they are not disrupted.

RIGHT: The great horned owl is among the state's many large birds of prey and can be seen in both woodlands and prairies.

FAR RIGHT: Two wild turkey toms strut for the hens in a springtime mating display.

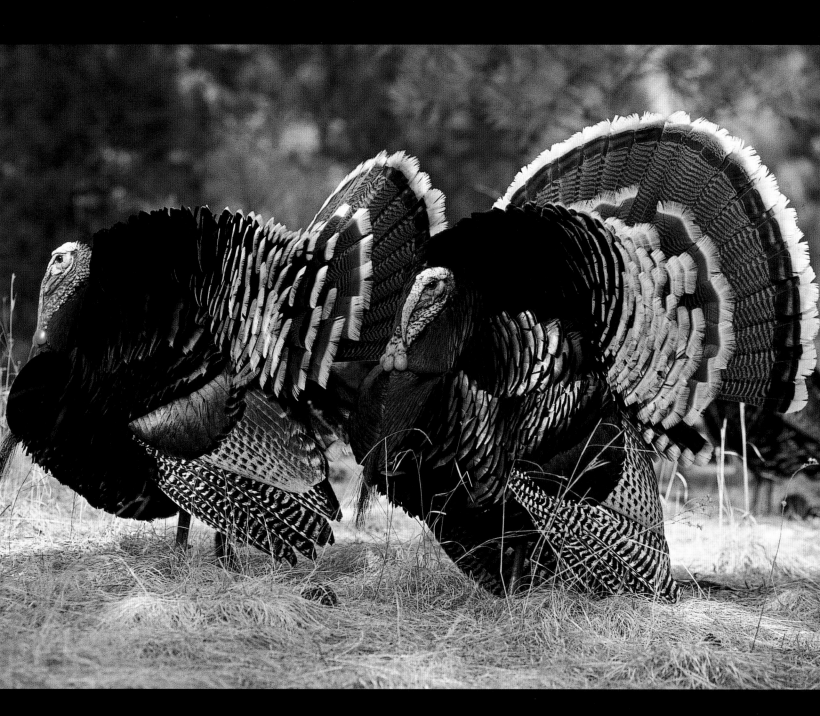

RIGHT: Known as Lame Johnny, this large pronghorn buck was a longtime resident of Custer State Park and a splendid example of his species. He was named as such because Lame Johnny Creek runs through what was his territory. He is believed to have died in winter a few years after this photograph was taken.

FACING PAGE: A week-old bison calf and his mother share a tender moment amid prairie wildflowers. About 60 pounds at birth, this little bison will grow to more than a ton—earning the species' rank as the largest land mammal on the North American continent.

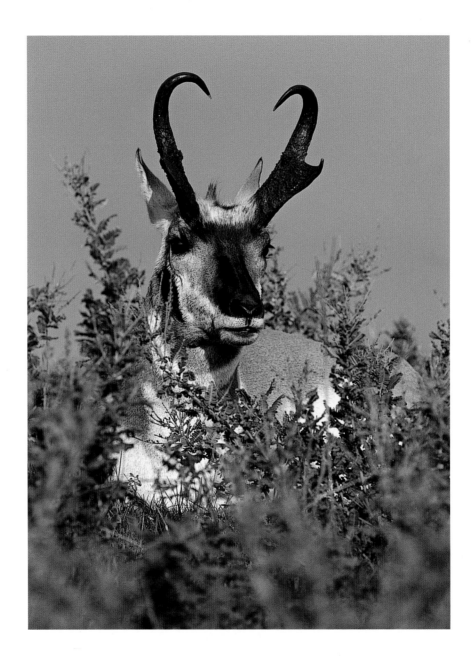

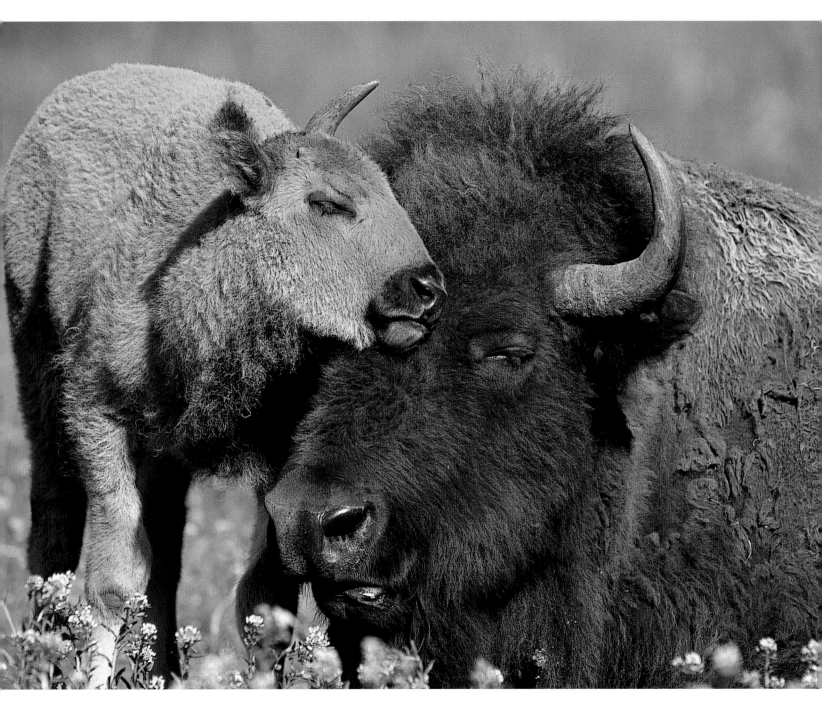

RIGHT: A white pelican comes in for a landing on a prairie lake.

BELOW: Ospreys are skilled at fishing and are commonly seen around the state's lakes and rivers during summer.

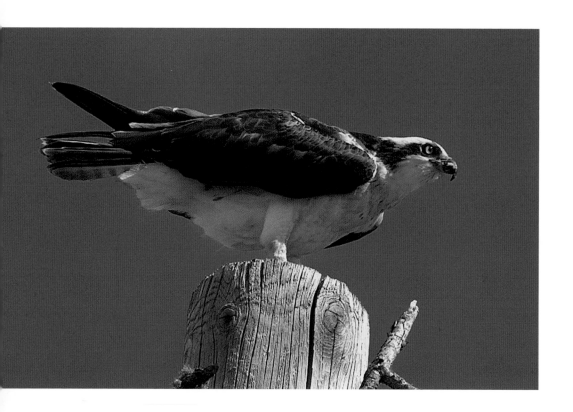

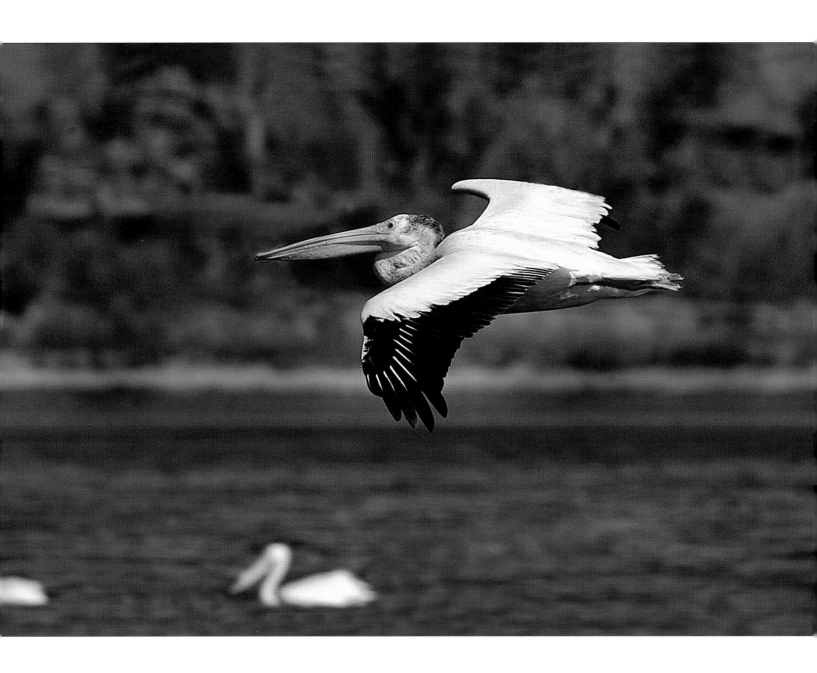

Animals that are normally very elusive, such as this young mule deer buck (right) and female coyote (far right), are a bit more tolerant of humans in winter because running away through the snow means expending critical energy.

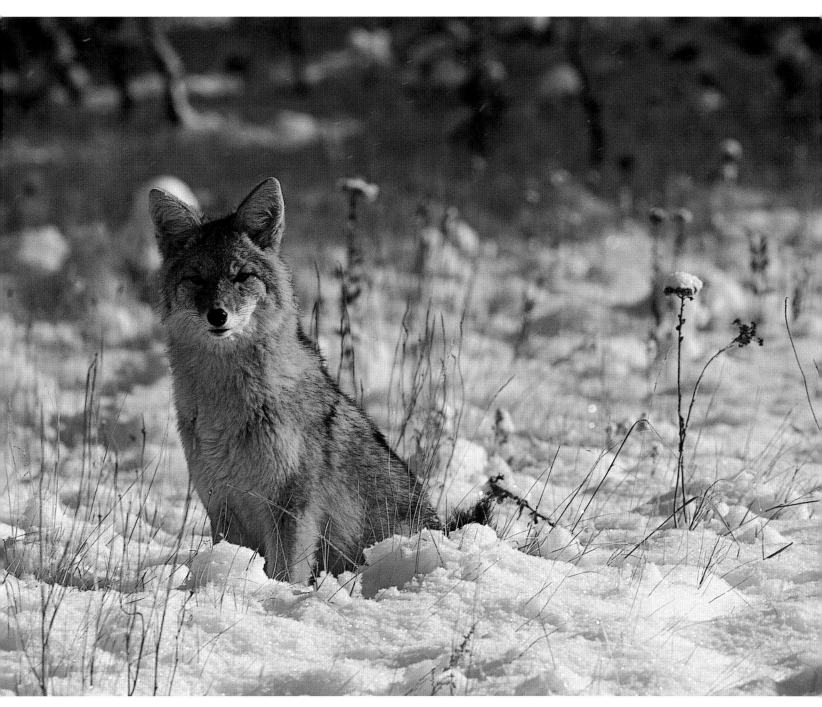

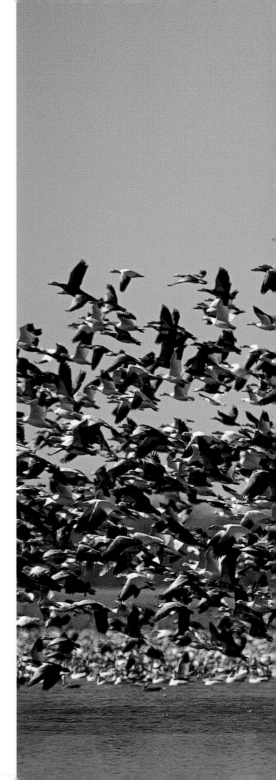

RIGHT: Thousands of snow geese take to the sky from the waters of the Sand Lake National Wildlife Refuge as they continue their annual northward trek in late March.

BELOW: A great blue heron searches for crayfish in a shallow pool along the Cheyenne River.

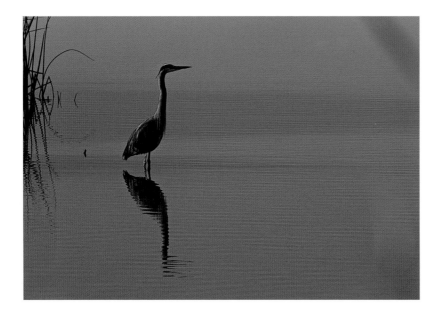

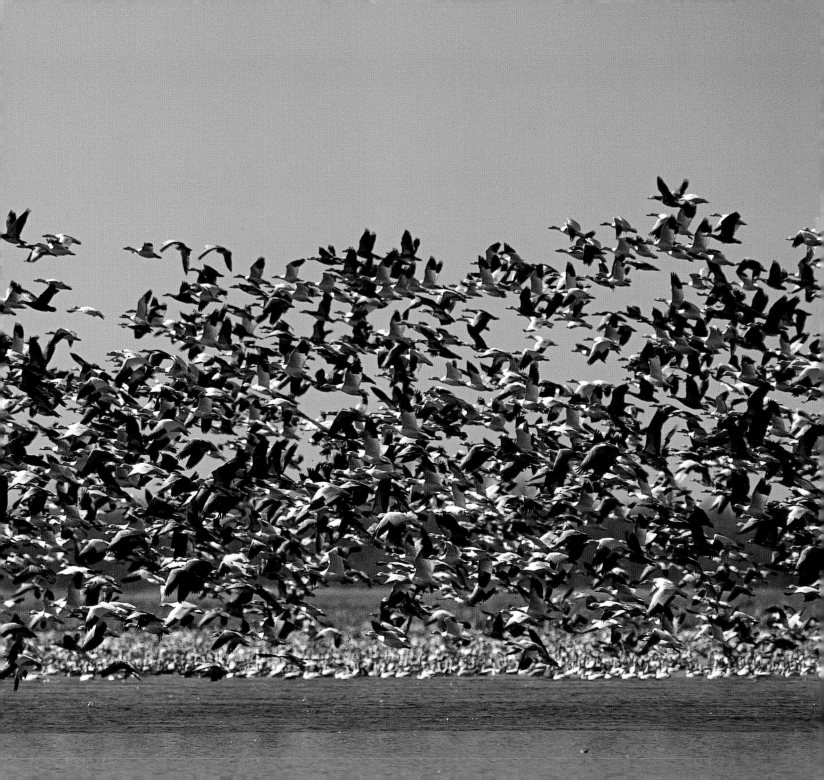

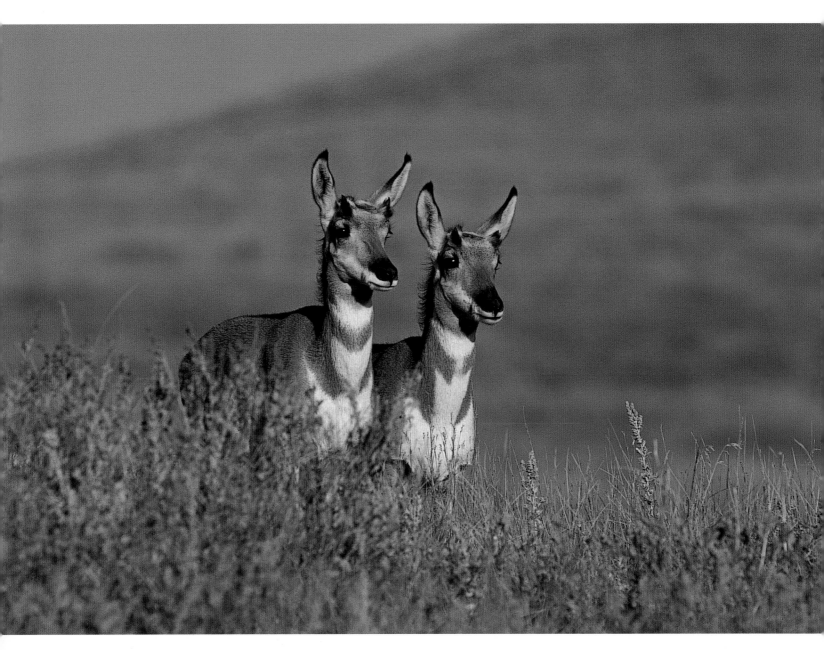

Now about three months old and sporting full adult coats, these twin pronghorn bucks are strong, healthy, and ready to enter their first winter.

RIGHT: The return of the western meadow-lark is one of the surest signs of spring across the high plains. It sings its melodic song throughout the summer from the rocks, shrubs, and trees of the grasslands before making its departure in autumn.

BELOW: Another common sound across the grasslands of the high plains is the barklike alarm call of the black-tailed prairie dog, warning of a predator's approach.

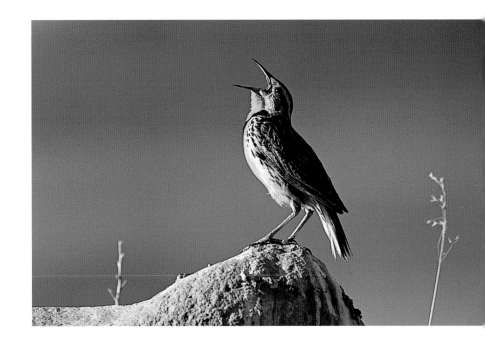

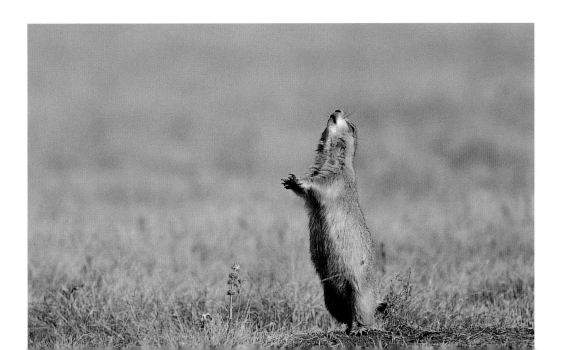

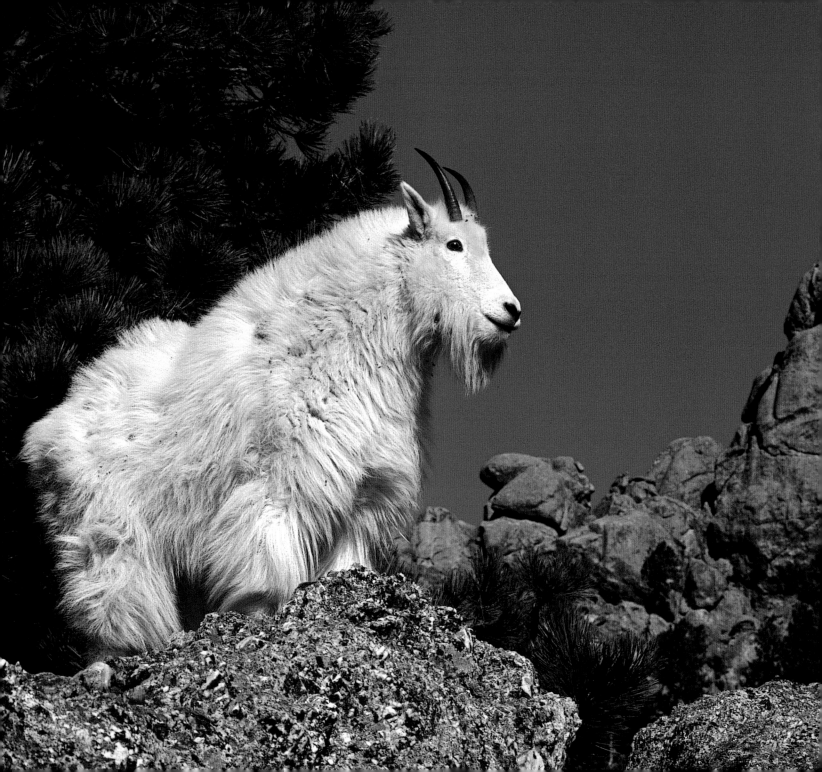

FACING PAGE: A mountain goat nanny basks in the warmth of the morning sun in the Black Hills' granite country. Mountain goats are not native to South Dakota; they were introduced into the state in the 1920s.

BELOW: A great blue heron feeds regurgitated minnows to its chicks. These shorebirds are residents of the South Dakota prairies only in the summer. The chicks grow fast because they must be ready to head south with the adults by summer's end. They migrate to wintering grounds in Texas, New Mexico, and Mexico.

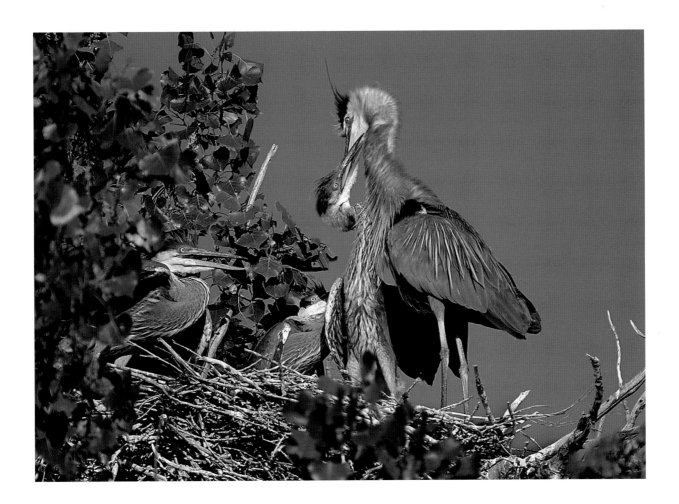

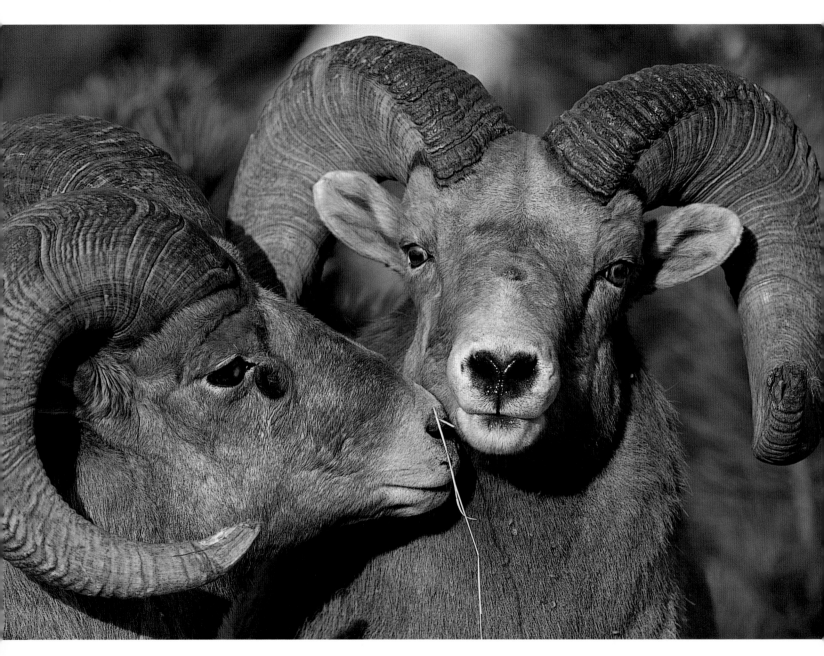

Bighorn rams employ a complex body language during their late-autumn rut. The ram on the left is submitting to the dominant ram by rubbing his head or horns against the other ram in a process known as "horning."

RIGHT: Note the marmot at the base of the rock outcropping. These ground-dwelling rodents feed on grasses during the day.
PHOTO BY SOUTH DAKOTA OFFICE OF TOURISM/CHAD COPPESS

BELOW: Another familiar bird of summer on South Dakota's prairies is the upland sandpiper, usually perched on fence posts or rocks.

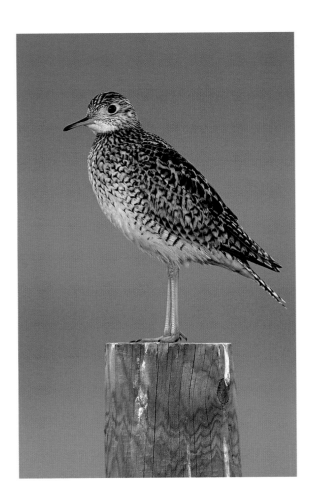

RIGHT: On Missouri River grasslands, two prairie chicken roosters compete for a mate by jumping above each other in a display of dominance.

BELOW: As it leans forward, spreads its wings, and drums its feet in a courtship display, a male sharp-tailed grouse shows the origin of its name.

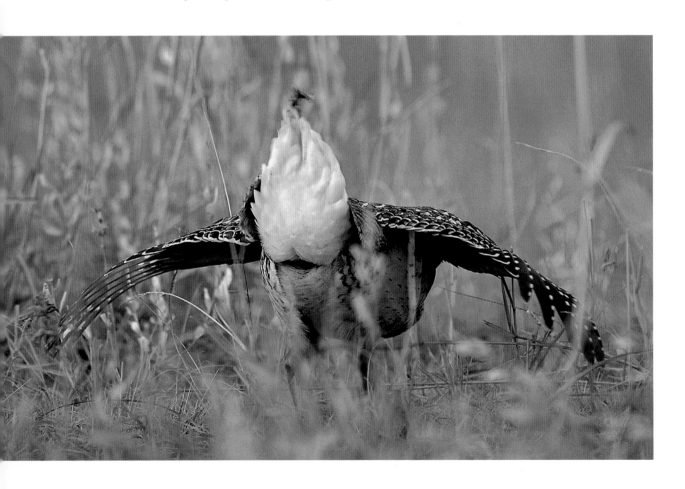

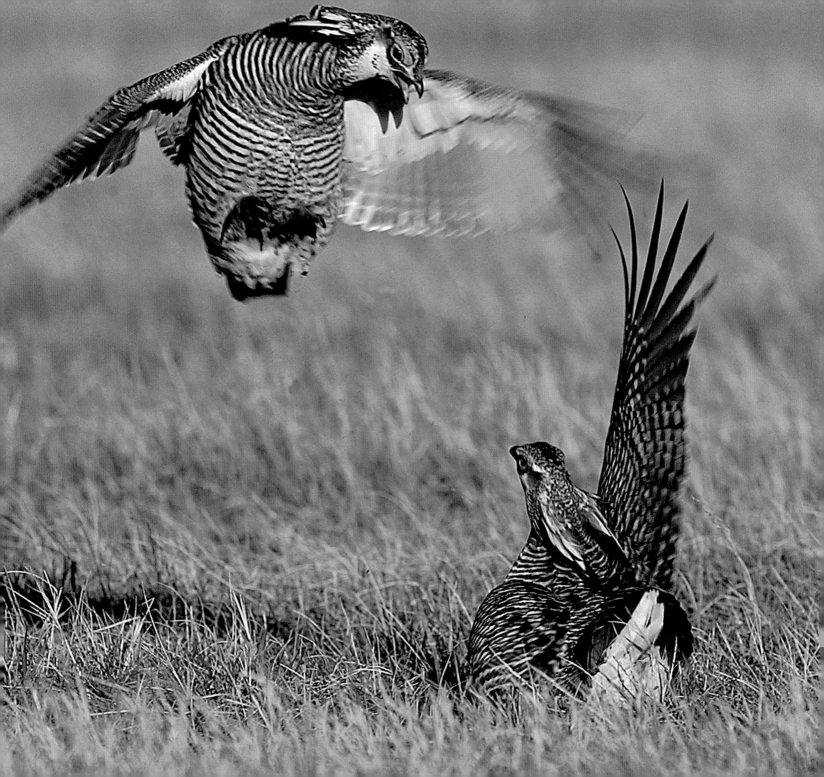

RIGHT: The killdeer is the most widely distributed plover in South Dakota, feeding on insects in sandy areas and on the surface of small ponds.

BELOW: A mallard duck drake takes an early morning swim across a prairie pond.

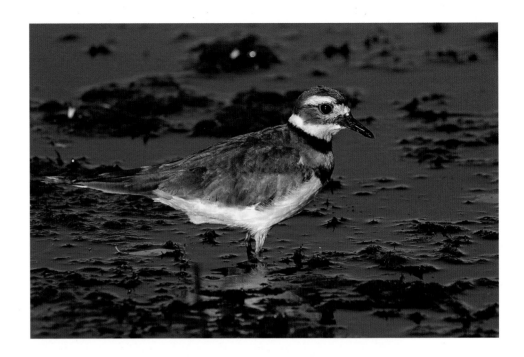

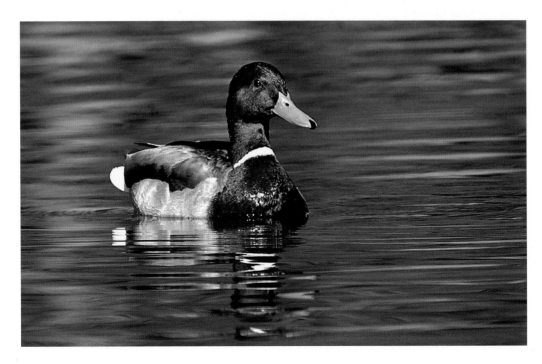

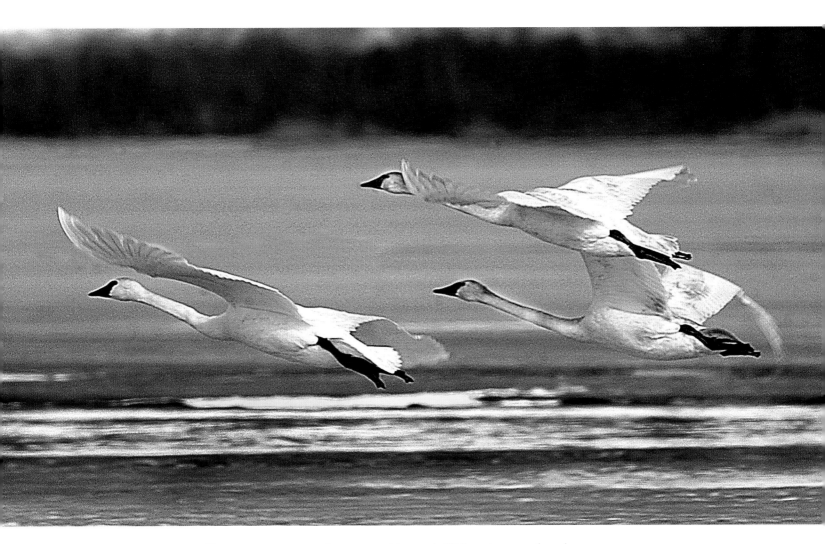

Three trumpeter swans fly over a prairie marsh. With a wingspan of nearly seven feet, these graceful birds are the largest waterfowl in the world.

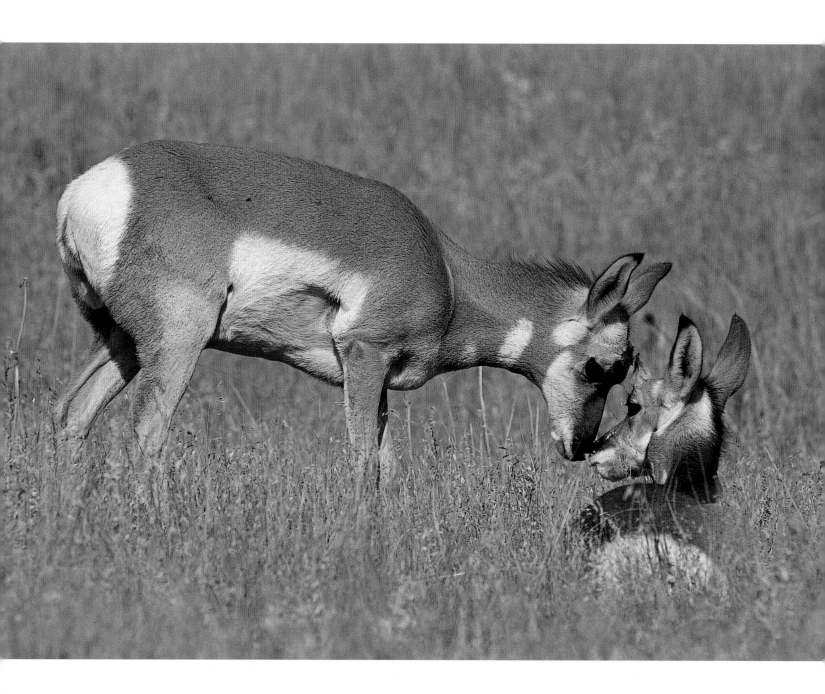

FACING PAGE: Pronghorn fawn siblings, a doe (left) and buck, share an affectionate moment.

BELOW LEFT: A tree squirrel poses for a portrait. PHOTO BY SOUTH DAKOTA OFFICE OF TOURISM/CHAD COPPESS

BELOW RIGHT: Though ranchers have little love for them, the black-tailed prairie dog is a favorite among tourists and wildlife observers for its antics.

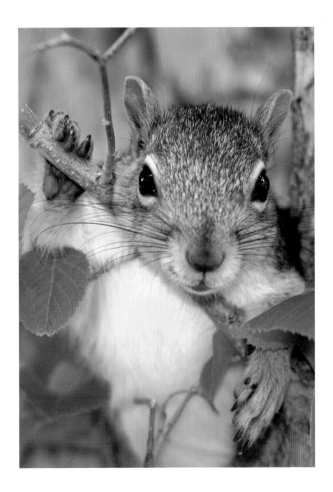

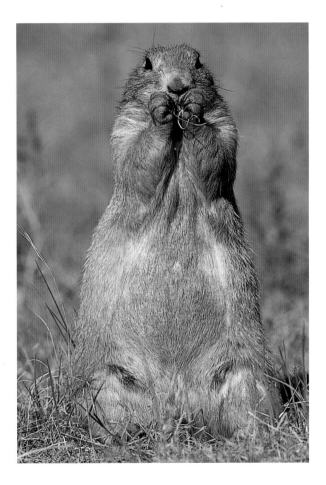

RIGHT: Elk cows walk in a long, winding column up a snowy ridge in Black Hills National Forest.

FAR RIGHT: A lone elk bull surveys the winter landscape of a southern Black Hills canyon.

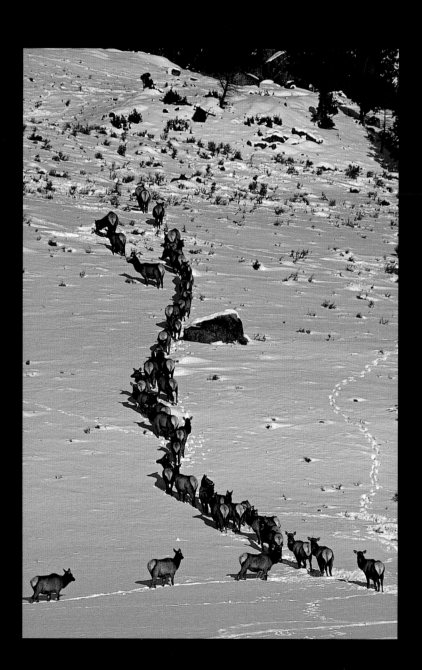

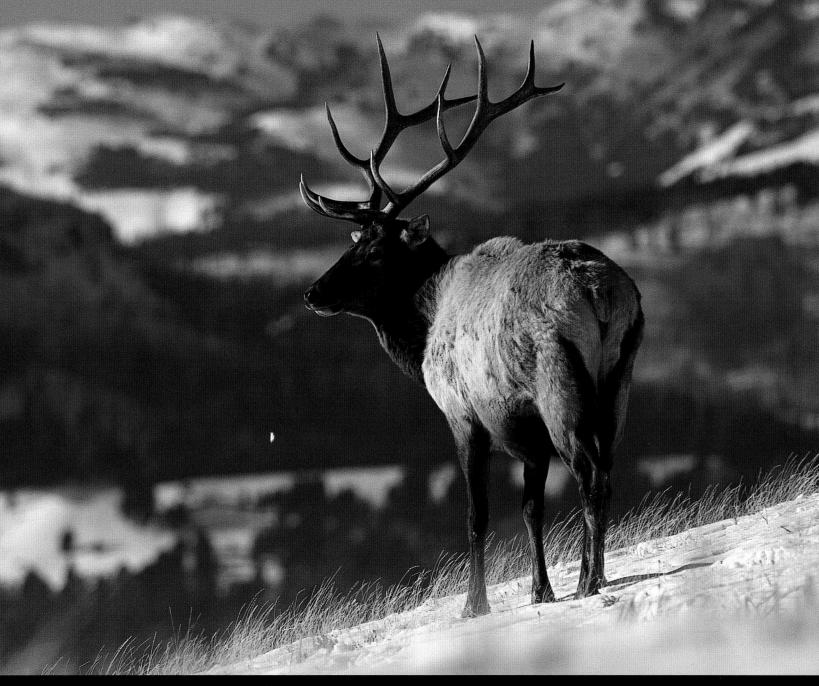

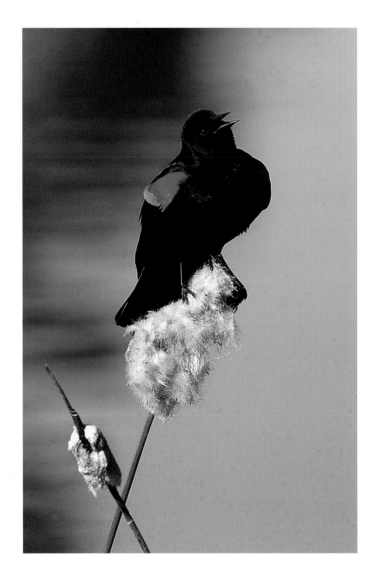

RIGHT: This red-winged black-bird may be celebrating the arrival of spring as he sings from his perch on a cattail.

FAR RIGHT: In the gorgeous light of dawn, a prairie chicken rooster struts for the hens on a lek in the Fort Pierre National Grassland.

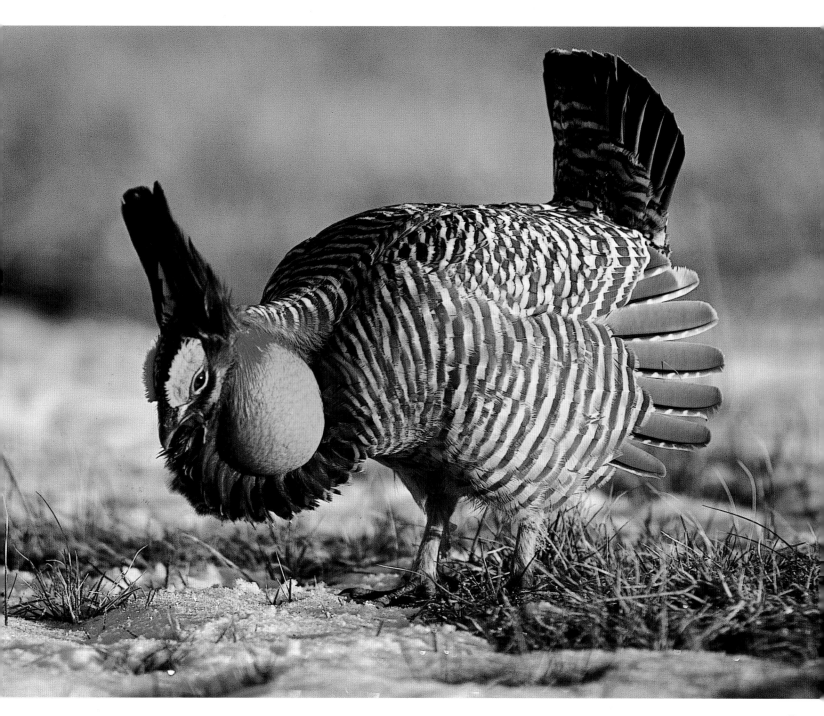

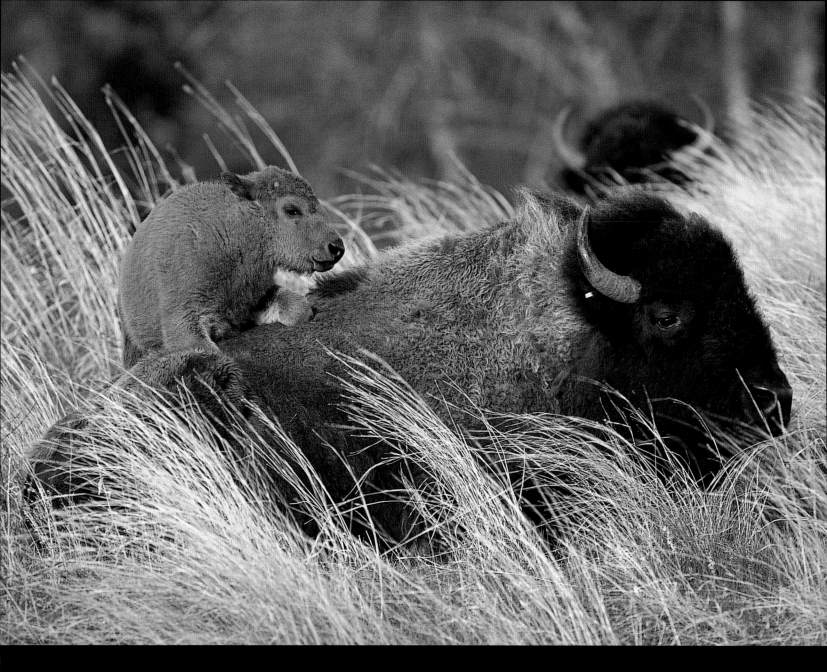

BELOW: Gregarious and playful, bison calves are fast to make friends among the other newborns.

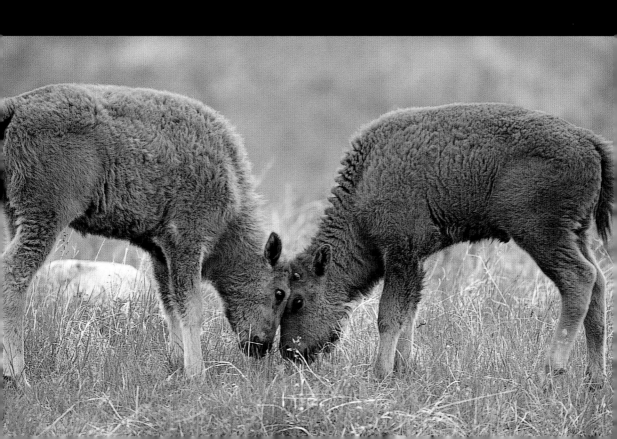

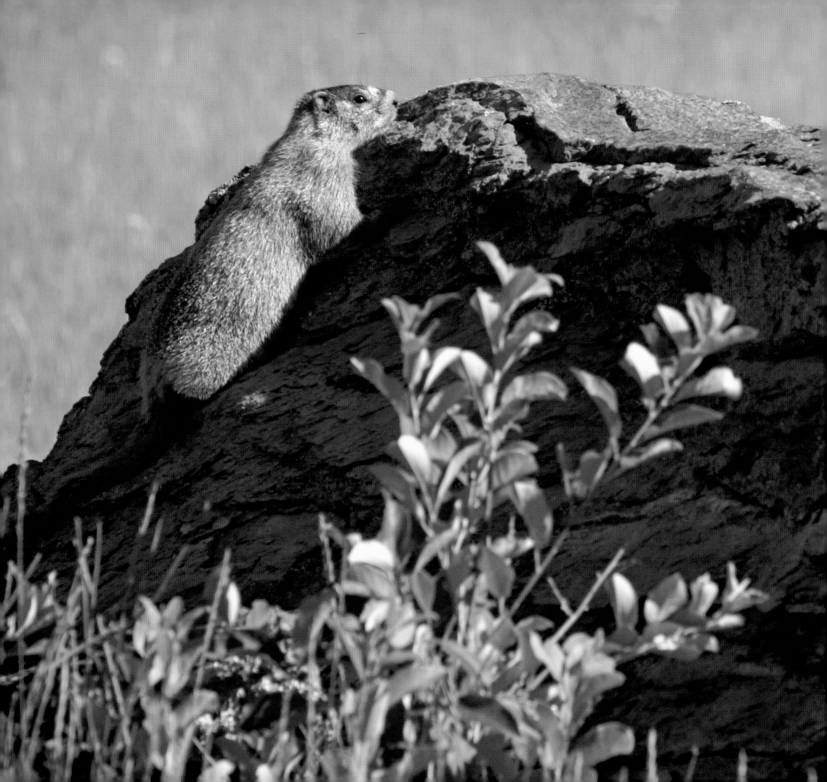

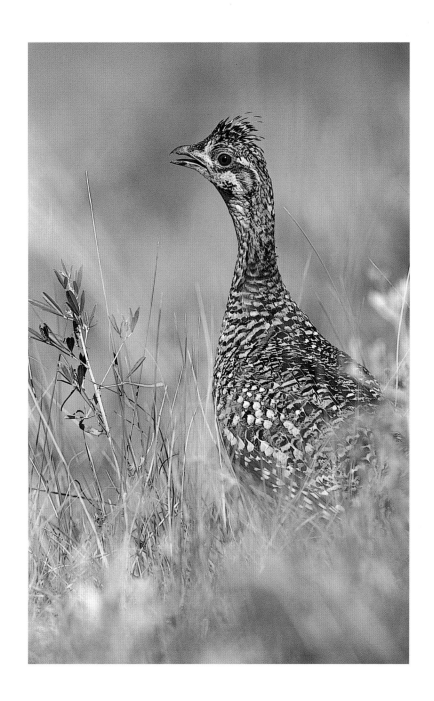

LEFT: A sharp-tailed grouse hen keeps a close vigil on her nest in the tall grass.

FACING PAGE: A marmot climbs a boulder for a better view of its surroundings.
PHOTO BY SOUTH DAKOTA OFFICE OF TOURISM/CHAD COPPESS

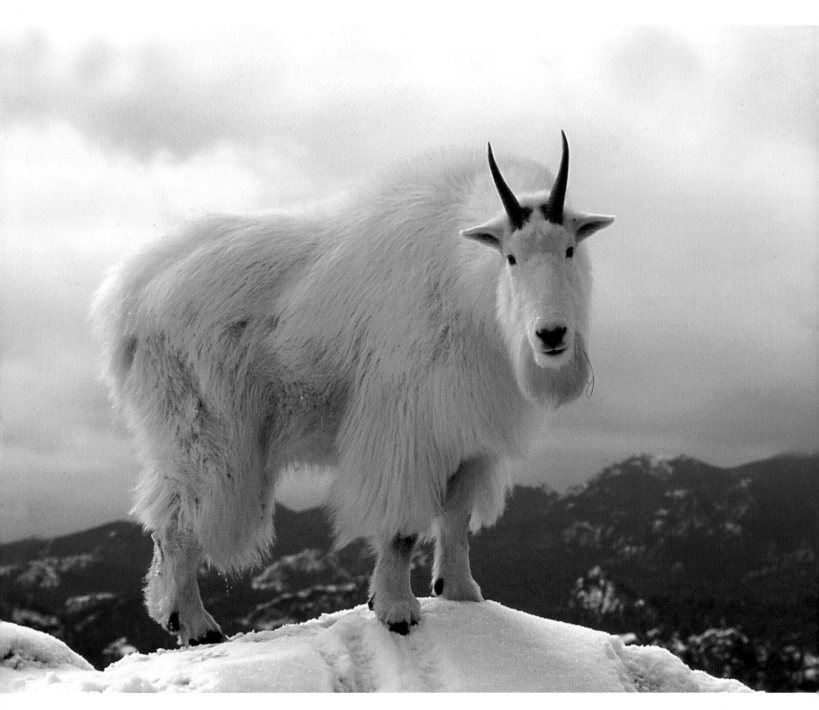

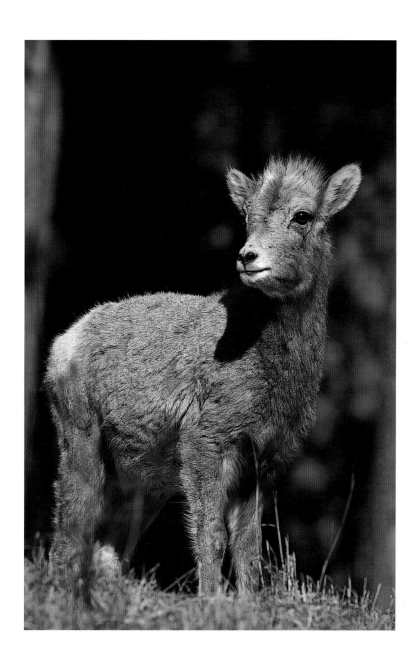

LEFT: At four months old, this bighorn sheep lamb is ready to enter its first winter.

FAR LEFT: Mountain goats are among nature's greatest mountaineers and have little trouble on the windswept granite peaks of the central Black Hills.

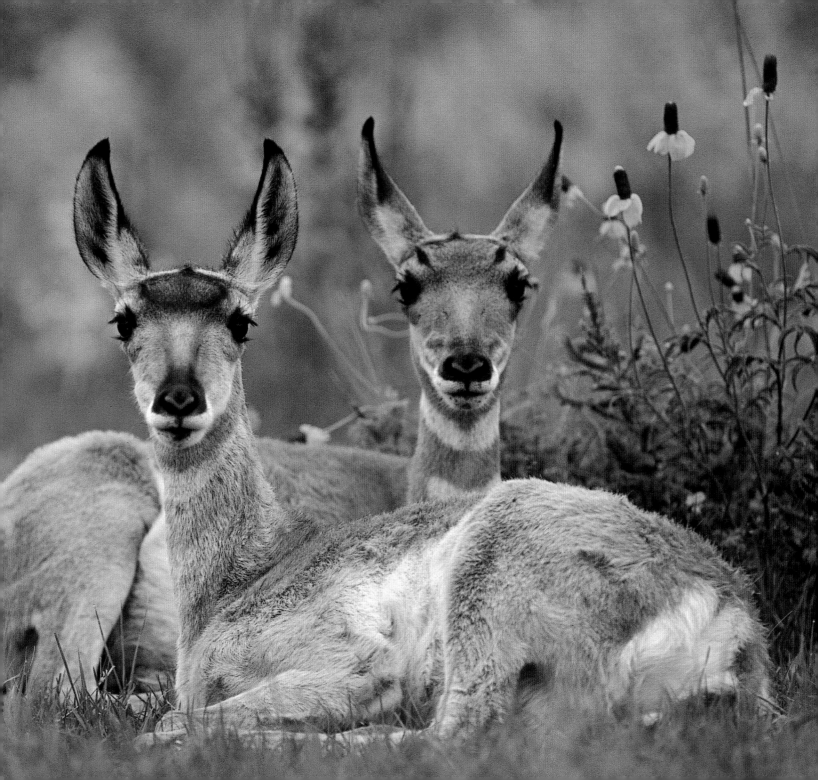

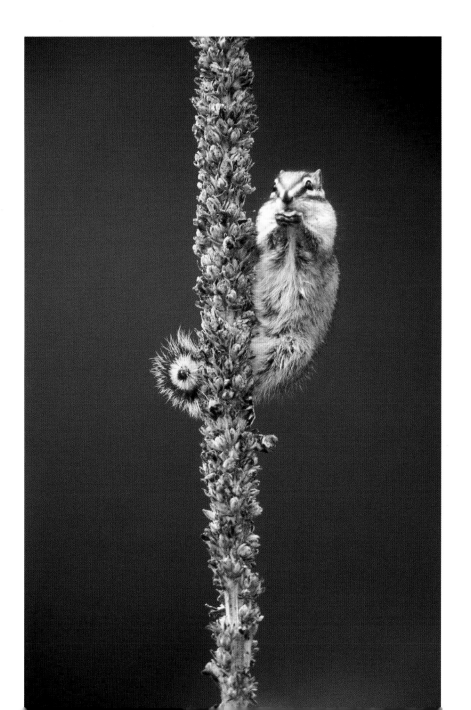

LEFT: A chipmunk uses its flat tail and hind feet to perch on a plant stem for a meal of seeds. PHOTO BY SOUTH DAKOTA OFFICE OF TOURISM/CHAD COPPESS

FACING PAGE: About ten weeks old, these twin pronghorn fawns spend their days in the open with the rest of the adults and are extremely curious. Multiple births are common among pronghorns.

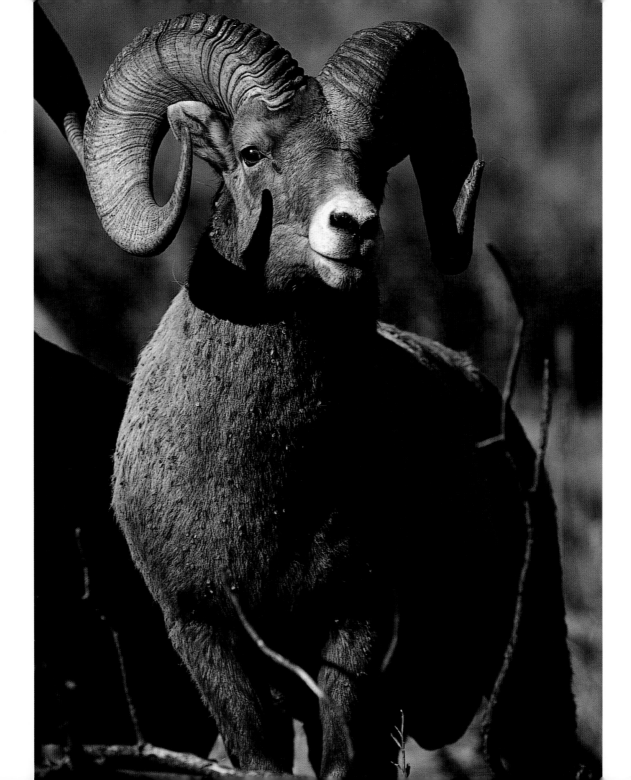

FACING PAGE: The coat of the bighorn sheep consists of short hair, not wool.

BELOW: The conical mound of dirt that surrounds a black-tailed prairie dog hole serves several functions, including keeping rainwater out of the burrow and providing a safe, elevated place from which to spot danger.

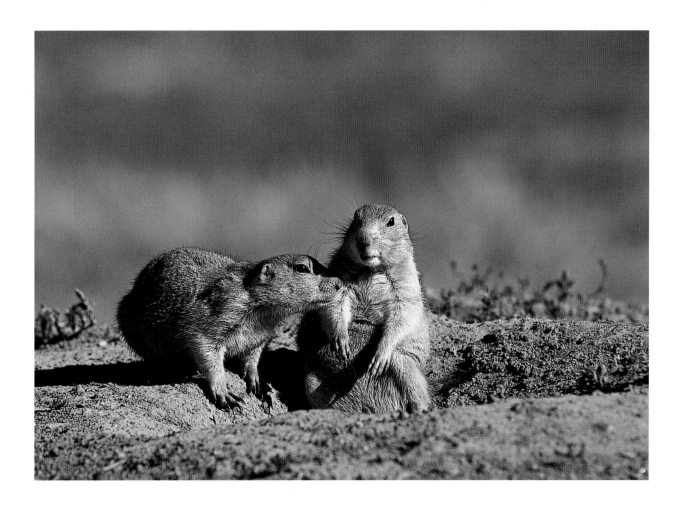

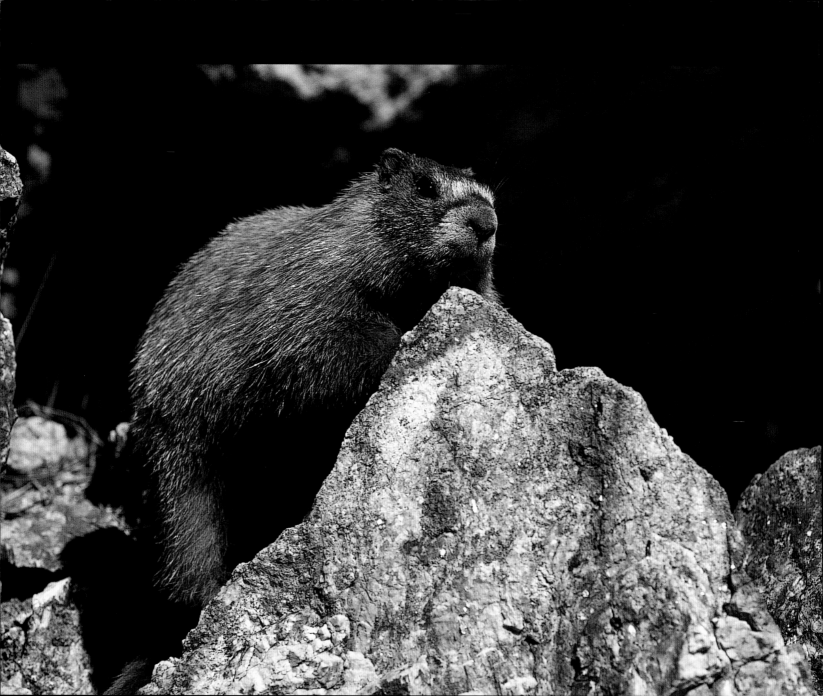

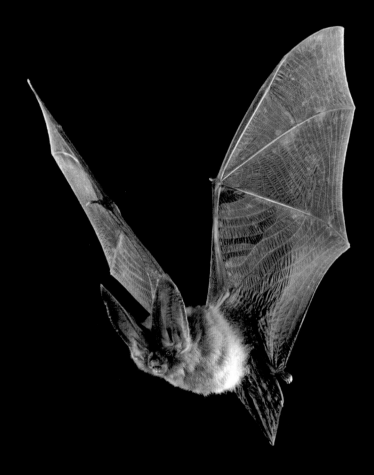

ABOVE: **The Townsend's big-eared bat roosts in caves and eats insects such as beetles, moths, and mosquitoes.** © MERLIN D. TUTTLE, BAT CONSERVATION INTERNATIONAL, WWW.BATCON.ORG

FACING PAGE: **The yellow-bellied marmot usually lives in small colonies along granite outcroppings in the Black Hills' high country.**

RIGHT: The pronghorn has two main tools of survival: its speed and its keen eyesight, which allows it to spot danger quickly. These remarkable creatures have been clocked at speeds of 65 mph, and they can maintain speeds of 35 mph for several miles.

BELOW: The jackrabbit, which is not a rabbit but a hare, sports long ears and powerful hind legs. PHOTO BY SOUTH DAKOTA OFFICE OF TOURISM/CHAD COPPESS

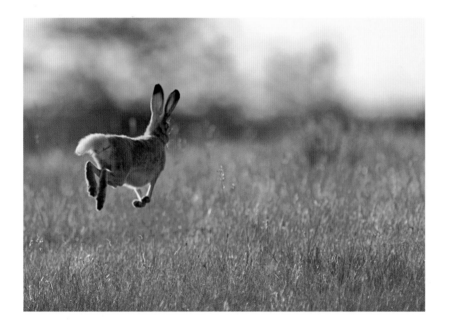

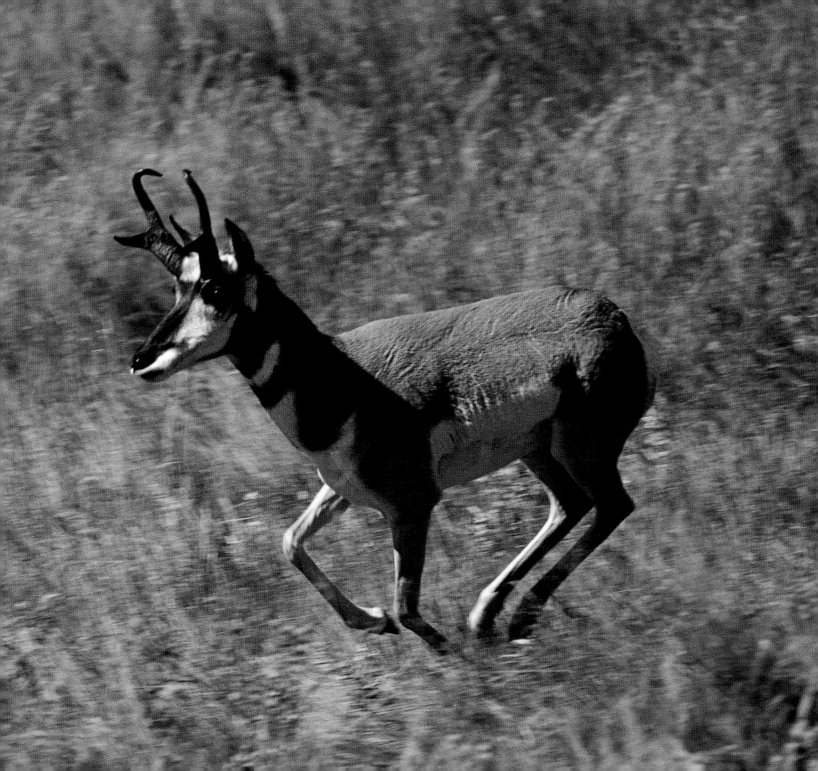

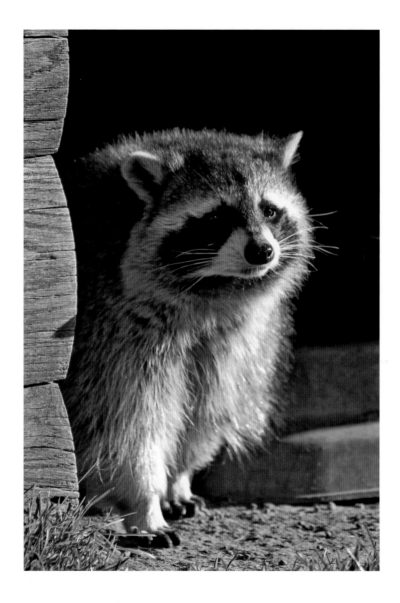

RIGHT: The raccoon is easily recognized by its black mask and bushy, ringed tail.
PHOTO BY SOUTH DAKOTA OFFICE OF TOURISM/CHAD COPPESS

FACING PAGE: First introduced to South Dakota in the 1890s, the ring-necked pheasant is the state bird and the most sought-after game species.
PHOTO BY DONALD M. JONES

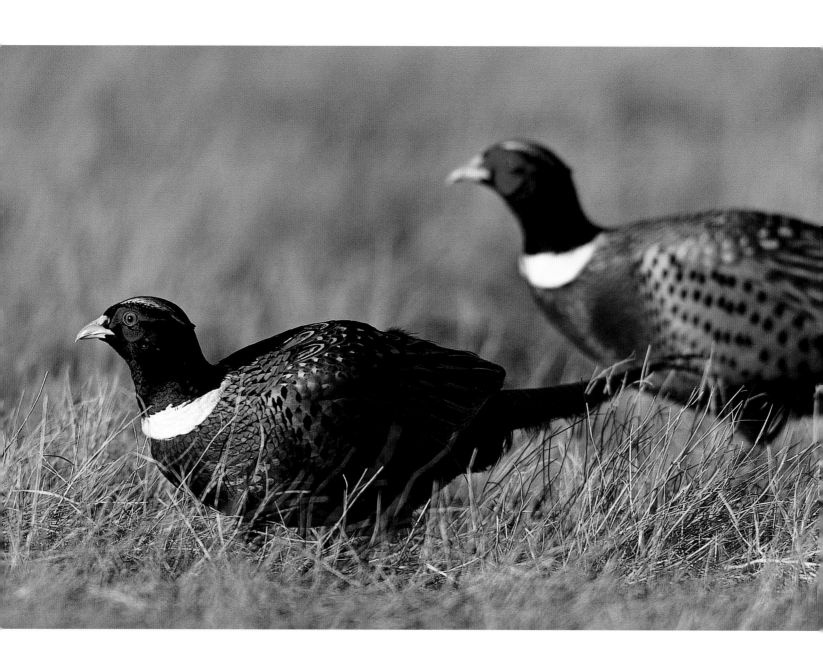

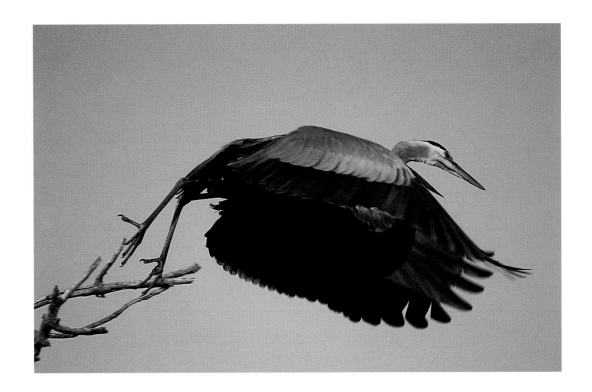

ABOVE: At summer's end, great blue herons head south for winter. They leave behind their huge nests, which can be seen in cottonwood trees across South Dakota.

RIGHT: A family of trumpeter swans walks across a frozen prairie pond. Young trumpeter swans are called cygnets. They are sooty gray for most of their first year, then develop the snow-white plumage of the adults.

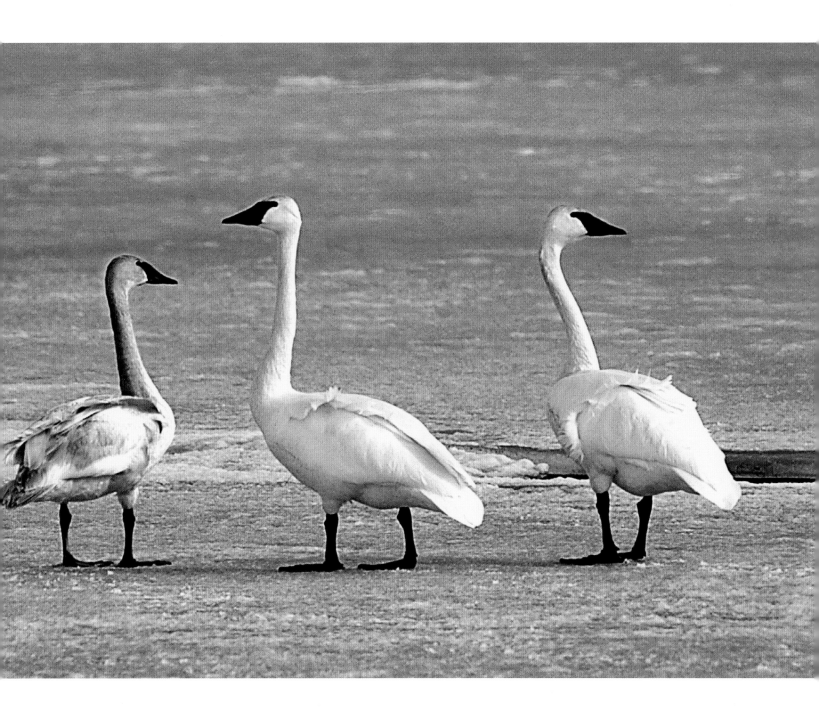

As daylight fades from a South Dakota marsh, three sandhill cranes land for the night.

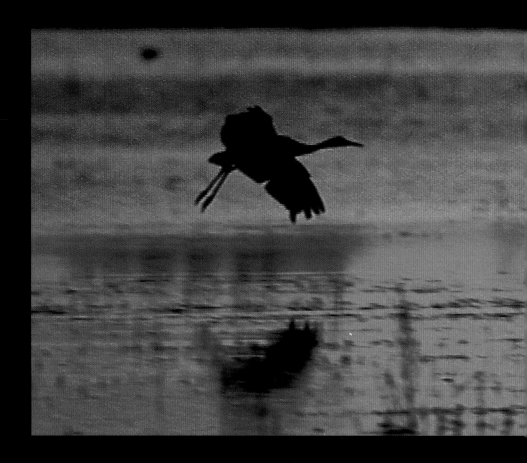

Dick Kettlewell's love for the American West began in childhood, before he had ever actually seen any of it. He was interested not in the mythical West of Zane Grey's literature or John Wayne's westerns, but the West that he saw in photographs: the stunning landscapes by Ansel Adams and Edward Weston, the *National Geographic* images of wild places. Kettlewell's idea of the West resembles that portrayed in the works of Aldo Leopold, Norman Maclean, and John Muir and in the journals of Lewis and Clark.

Kettlewell's photographic roots are in photojournalism, and he has worked for mid- and metro-sized daily newspapers for more than twenty-five years. Currently, Dick produces a regular photographic column called "The Spring Creek Chronicles" for the *Rapid City Journal.*

PHOTO BY STEVE MCENROE

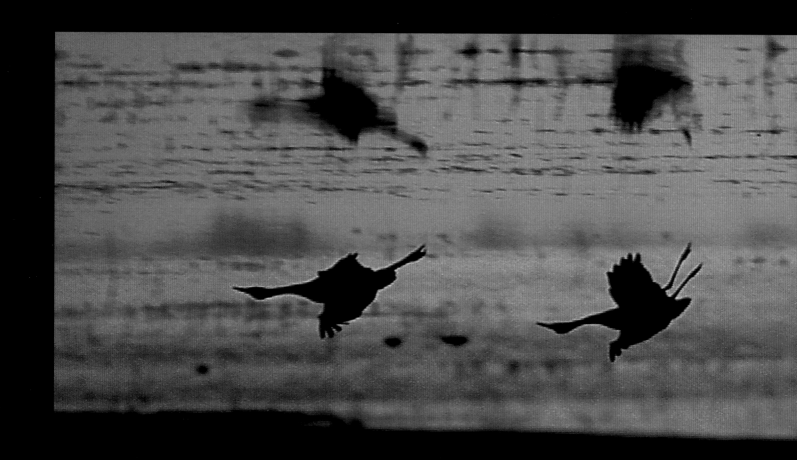